The Original PINK FLAMINGOS

Splendor on the Grass

Don Featherstone

Text by Tom Herzing

Schiffer Publishing Ltd

4880 Lower Valley Road, Atglen, PA 19310 USA

Design by Blair Loughrey
Typeset in: Nevison/Kabel/Zurich

ISBN: 0-7643-0963-3
Printed in China

Published by Schiffer Publishing Ltd.
4880 Lower Valley Road
Atglen, PA 19310
Phone: (610) 593-1777; Fax: (610) 593-2002
Please visit out web site catalog at **www.schifferbooks.com**
or write for a free catalog.
This book may be purchased from the publisher.
Please include $3.95 for shipping.

In Europe, Schiffer books are distributed by
Bushwood Books
6 Marksbury Rd.
Kew Gardens
Surrey TW9 4JF England
Phone: 44 (0)181 392-8585;
Fax: 44 (0)181 392-9876
E-mail: Bushwd@aol.com

Please try your bookstore first.

We are interested in hearing from authors
with book ideas on related subjects.

Contents

Introduction

Few imagined the evolutionary cusp on which the civilized world teetered in 1957, when the threat of an atomic holocaust, cures for poliomyelitis, and the pneumatic charms of Rita Hayworth occupied the daily attention of professors and pundits. Unknown to all but a few, in that fateful hour was born an entirely new avian species, *phoenicopteris ruber plasticus*, the love child of Don Featherstone's fertile imagination. Later to be known colloquially as The Original Pink Plastic Flamingo, *phoenicopteris* was to inspire admirers, infuriate critics, engender fan clubs, evoke poetry, and even (it is rumored) lead to unbridled song. *Avoe* to the *ava*!

The paths of evolution have wended their silent ways for untold eons, leading life forms to crawl from sea to land, to rear themselves upright, to create grocery store tabloids, dental floss, advertising for personal hygiene sprays, and the United States Congress.

Throughout recorded history, humankind has had a burning desire to decorate. Cave paintings, the Pyramids, Phidias's and Michaelangelo's statues, Vermeer's and Rembrandt's portraits, and statutes of the Blessed Virgin posed in bathtubs may not be artistically equal, but they all are illustrations of our desire to beautify our environment.

The 19th century saw the creation of cast iron lawn ornaments and concrete statuary as an affordable alternative to costly and delicate marble originals. In the 1950s, the ubiquity of plastics technology permitted the creation of two-dimensional, virtually indestructible lawn ornaments. In 1957, Don Featherstone sculpted the first three-dimensional pink plastic flamingo, thereby making affordable bad taste accessible to the American masses.

Since then, more than 20,000,000 pairs of pink plastic flamingos have landed on lawns and other improbable roosts. The only significant change to the original design of *phoenicopteris* took place in 1986 when Don Featherstone's signature was engraved (with no apparent sense of irony) under the bird's tail.

America, as this volume so persuasively demonstrates, has developed a Pink Plastic Flamingo subculture, replete with rituals, rumors, and rites (none involving carcinogens as far as we can tell and all, thankfully, of no evident interest to the researchers at the Masters and Johnson Institute at Indiana University). So elemental a part of our culture has Featherstone's flamingo become (which, unlike his far less famous duck, is *not* anatomically correct) that this winner of the 1996 Ig Noble Prize from *The Annals of Improbable Research* has even inspired a creative vendor to sell midnight raids which deposit unexpected flocks of pink plastic flamingos (we haven't had time to check with former Vice President Quayle to ascertain whether the plural of *flamingo* deserves an "e," or whether that is reserved for the singular) on the lawns of selected victims in Chicago, Cleveland, Atlanta, San Francisco, and Oklahoma City to name a few.

What *phoenicopteris* has inspired is humor and something akin to veneration. Respect, however, is too much to ask. The pictures which follow are a result of Don Featherstone's request that on the 40th birthday of the pink plastic flamingo owners send original pictures that demonstrated their affection for this unique creation. The response was overwhelming; in this volume you will see slightly more than 100 of the many pictures he received. The result of Featherstone's quest is sometimes humorous, sometimes touching, always enlightening.

1
The Non-Migratory phenicopteris ruber plasticus

Experts have long been baffled by the fact that the pink plastic flamingo does not appear to have a migratory instinct. After millions of years of coping with Mr. Darwin's theory of evolution, his natural counterparts have been so weakened that they are confined to foraging for nourishment among the cigar stubs at tropical Florida racetracks.

"Real" flamingos immediately head for the equator at the first hint that Floridian temperatures might plummet below levels necessary to fry the average avian brain.

Not so with our heroic friend. It is common to find *ruber plasticus* surrounded by, coated by and—if one digs with archaeological care—covered by Northern snows. A williwaw that would drive a Tinglit to his lodge house is a mere breeze to the brazen beast.

The adventurousness of the pink plastic flamingo has captured the hearts of his many fans. Few images strike so deeply into the core of our affections as scenes in which our rubicund hero stands proud and unshaken amidst piling snows, unflinching before the cutting winds of a Canada clipper, undaunted by a gale. Amidst these environmental inquisitions, *ruber plasticus* stands deep in thought.

Even more impressive is the fact that at times our blushing friend serves as an exemplar to his nominal masters. Moved by his stoic endurance and often fueled by immoderate quantities of highly refined alcohol products, you can see *ruber*'s admirers disporting themselves, nearly unclad, amidst the occasional snow bank and—more commonly—at professional football games played by teams that eschew covered stadia in Northern winters as the residences of cowards, charlatans, and wimps.

No risk that the subtle intellect of the pink plastic flamingo will be corrupted by tropical heat or poisoned by the stogies left behind by race track touts. Unless launched on one of his frequent vacations or adventures, *phoenicopteris ruber plasticus* stands firm.

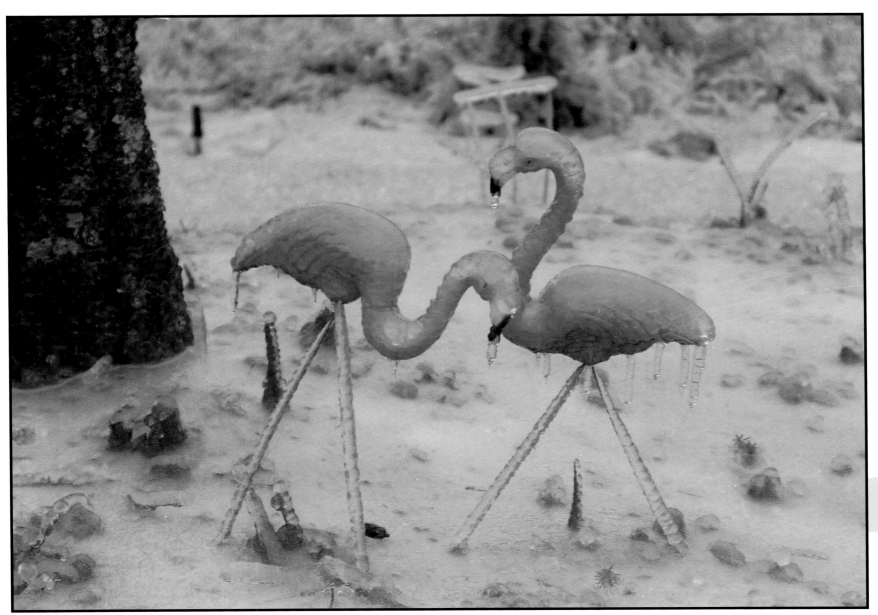

Too Cool

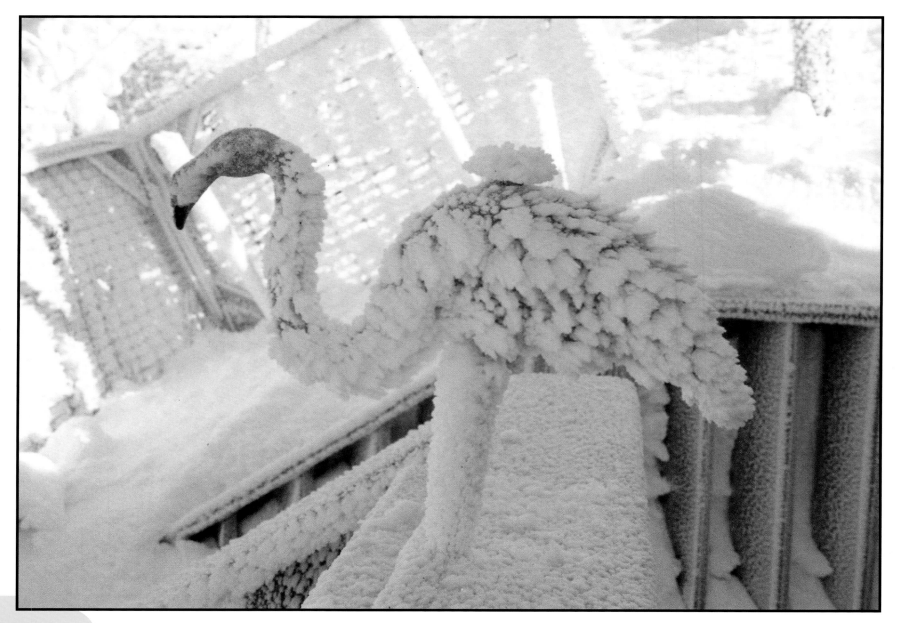

Snowbrrrd

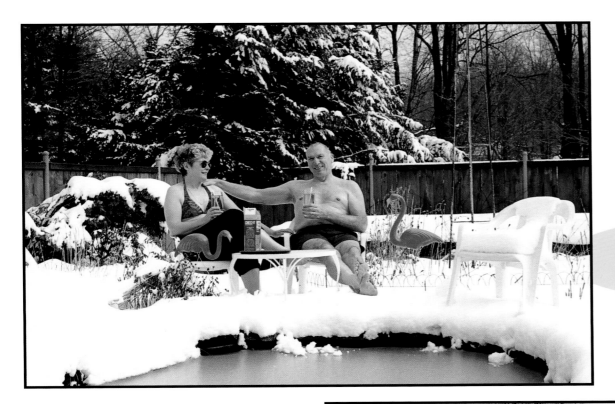

Our Retirement Paradise in the Sun

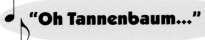

♪ *"Oh Tannenbaum..."*

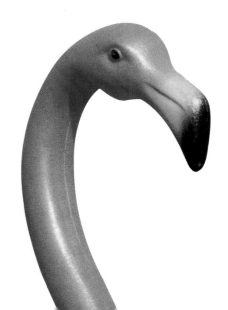

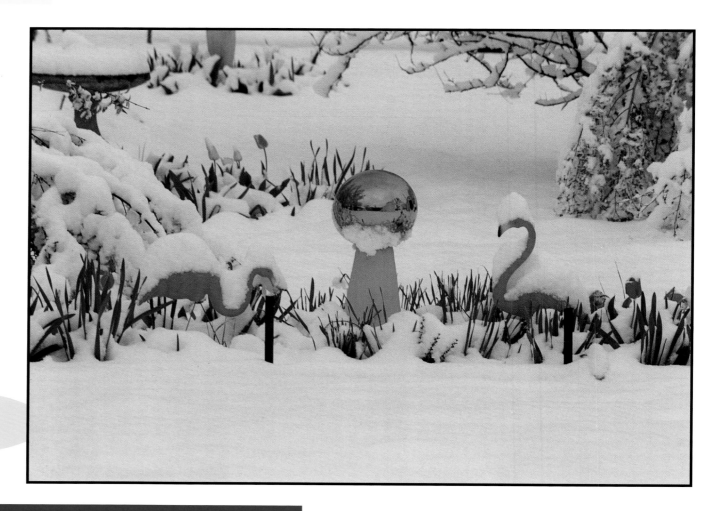

Winter Blues

Few images strike so deeply into the core of our affections as scenes in which our rubicund hero stands proud and unshaken amidst piling snows, unflinching before the cutting winds...

Should Have Taken a Left

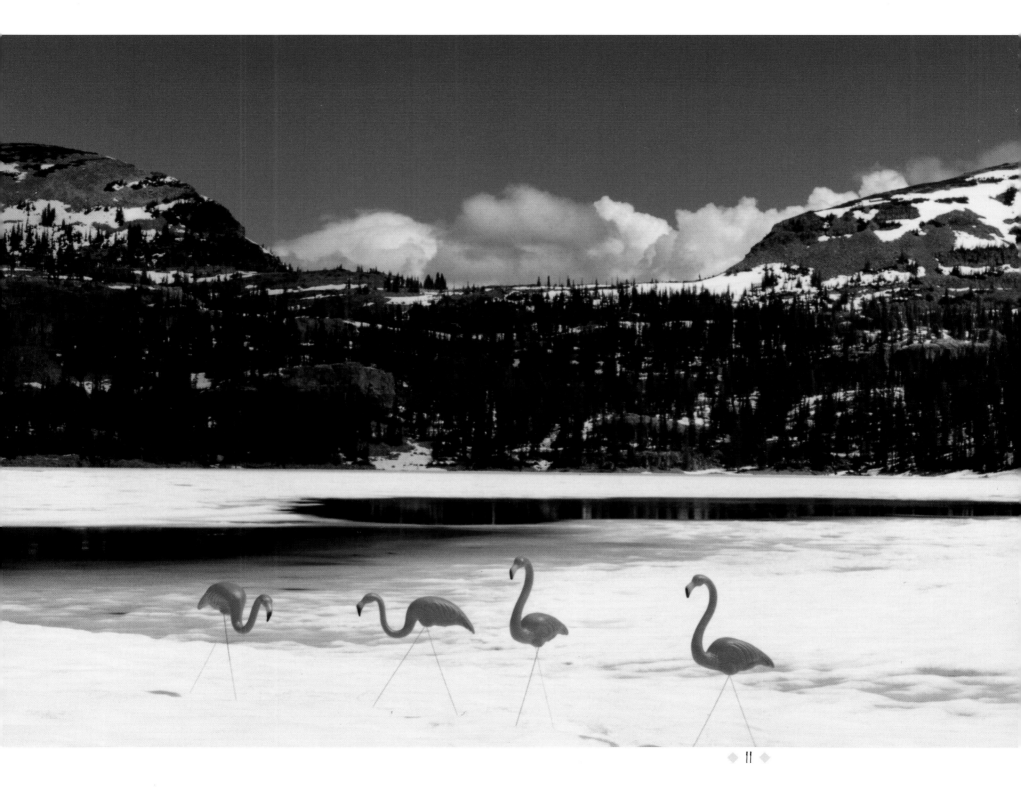

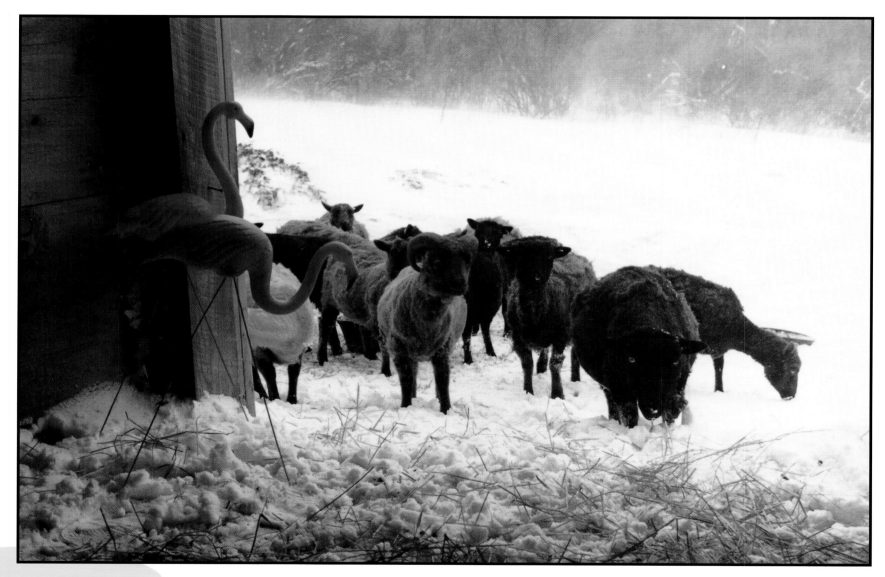

Let's Take It on The Lamb

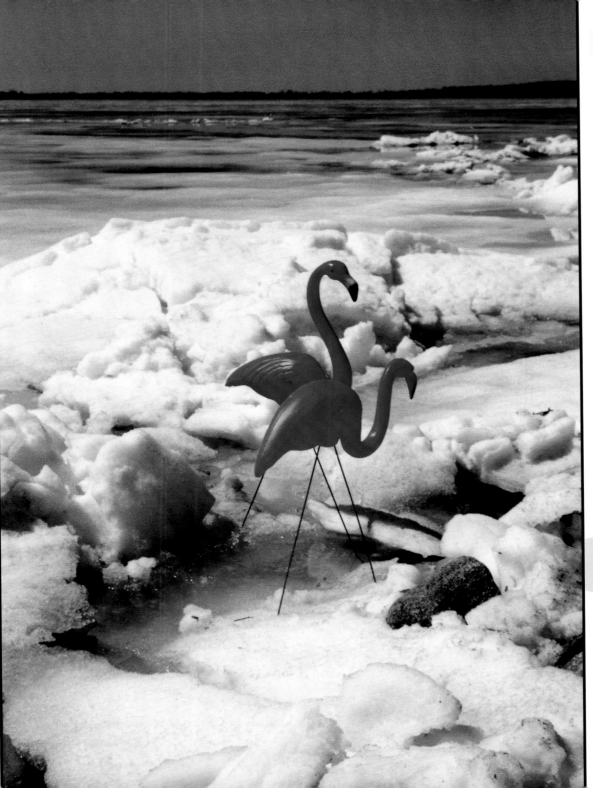

The Non-Migratory phenicopteris ruber plasticus

Go With the Floe

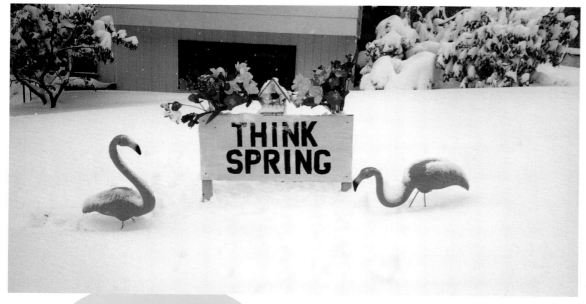

Wishful Thinking

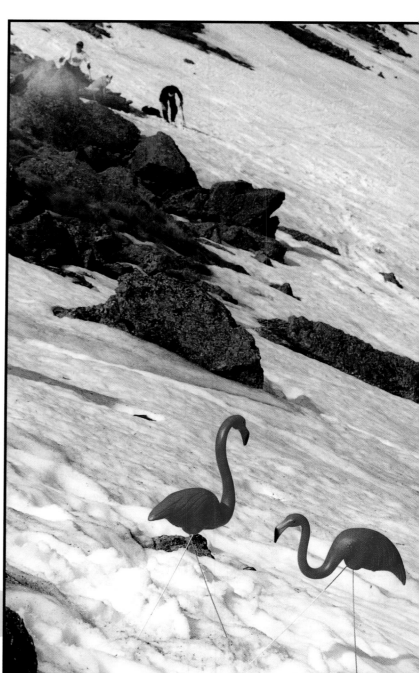

Cold Feet

"Go Nest, Young Man"

2

The adventurousness of *phoenicopteris ruber plasticus* is legend.

When Frederick Jackson Turner declared that the Wild West was civilization's last frontier, hundreds of pink plastic flamingos hiked off, steel-legged and clear eyed, to settle and tame the rough cities thrown up by dogie-pokers and sod-busters. Amazingly, dozens of color photographs still survive chronicling these brave pioneers and their culture.

Few people realize that a rogue *plasticus* rode with the James Boys during their famous and fatal raid on Northfield, Minnesota. When the angry citizens let loose with their hidden Peacemakers, Greener double-barrel shotguns, and Sharps rifles, only this outlaw pink plastic flamingo was unhit, having almost instantly posed near a watering trough as a ruse. For years, he lived peaceably in the backyard of a certain Widder Jones, who used him instead of a more conspicuous red light on the porch.

As Butch Cassidy and Sundance fled for South America, they were dogged by a rough-and-ready posse of hatted and neckerchiefed flamingi. Being by nature as peaceable as the Brethren, *ruber plasticus* carried no weapons, depending entirely on their speech-making to bore miscreants into surrendering, much in the way of politicians.

In modern times, more and more pink plastic flamingos have found their homes in the West. Few of these are retirees, as far as we can determine, since the Environmental Protection Agency has declared *ruber plasticus* non-biodegradeable. Many humans over the age of 45 would dearly love to have such a designation.

Rather, the rosy rogues seem to be seeking icy high adventure in the mountains and the hot challenge of the deserts. Because of their lack of knee joints, plastic flamingos are prohibited from mountain biking and several other environmentally deleterious activities. Unfortunately, this also means teenage plastic flamingos cannot participate in hacky-sacking and other forms of inter-cultural exchange.

As a result, the pink plastic flamingos of the West have settled into isolated communities where they can contemplate nature and work on physical fitness and channel with recycled beverage bottles. Because of their peacefulness, they are occasionally preyed on by more aggressive species and they are sometimes hunted as game and food.

Few of these predators remember *phoenicopteris'* contribution to the settling of America's last frontier...the flamingos who heeded the call to "go nest, young man."

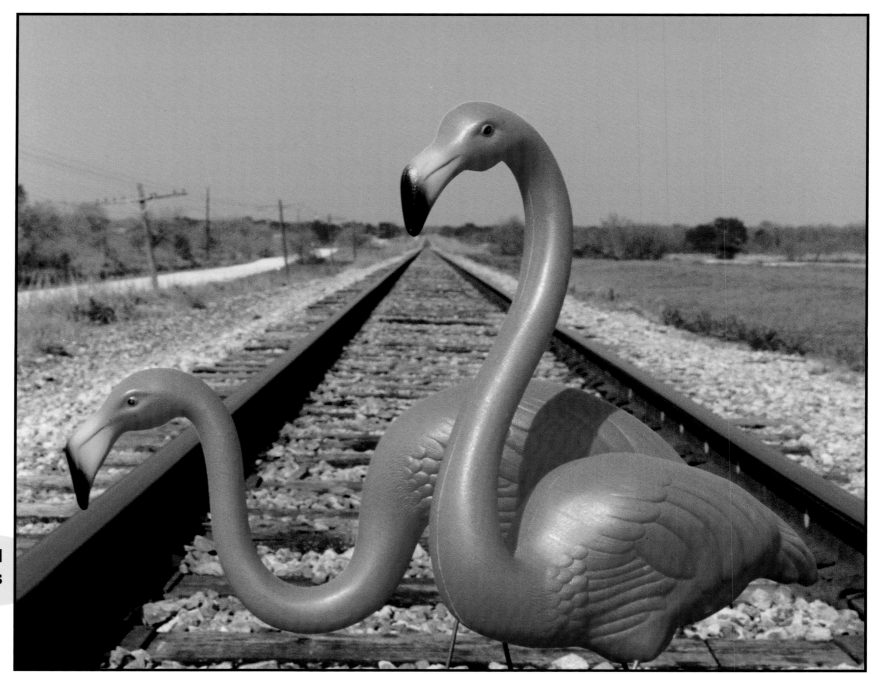

Trained Flamingos

Rim Shot

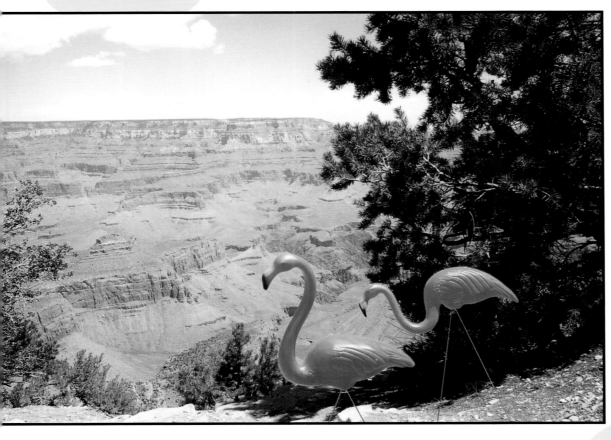

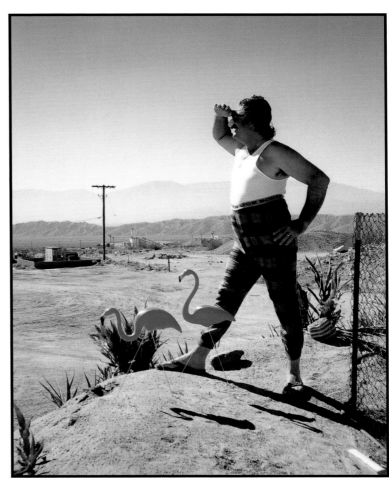

Who Hired This Guide?

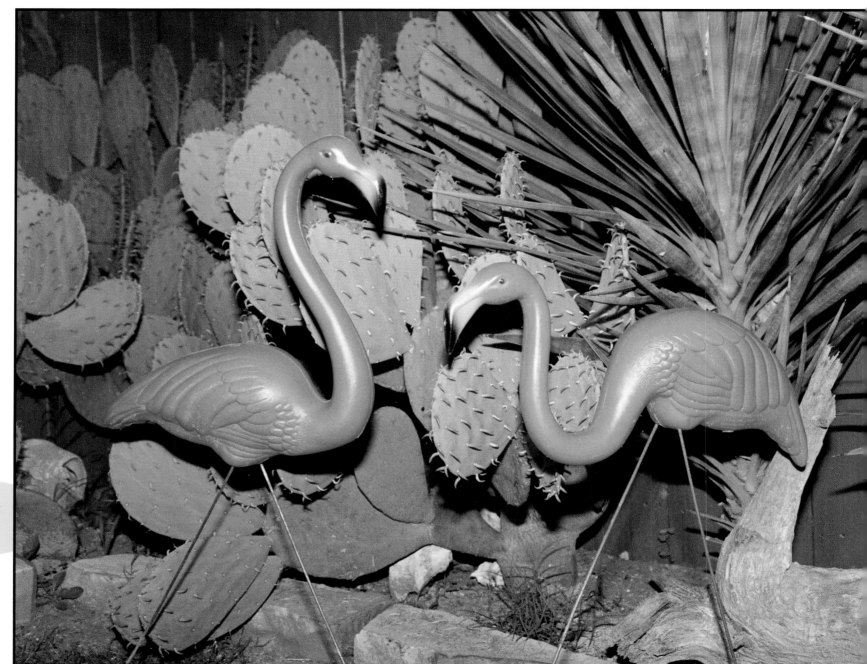

You Prickle My Fancy

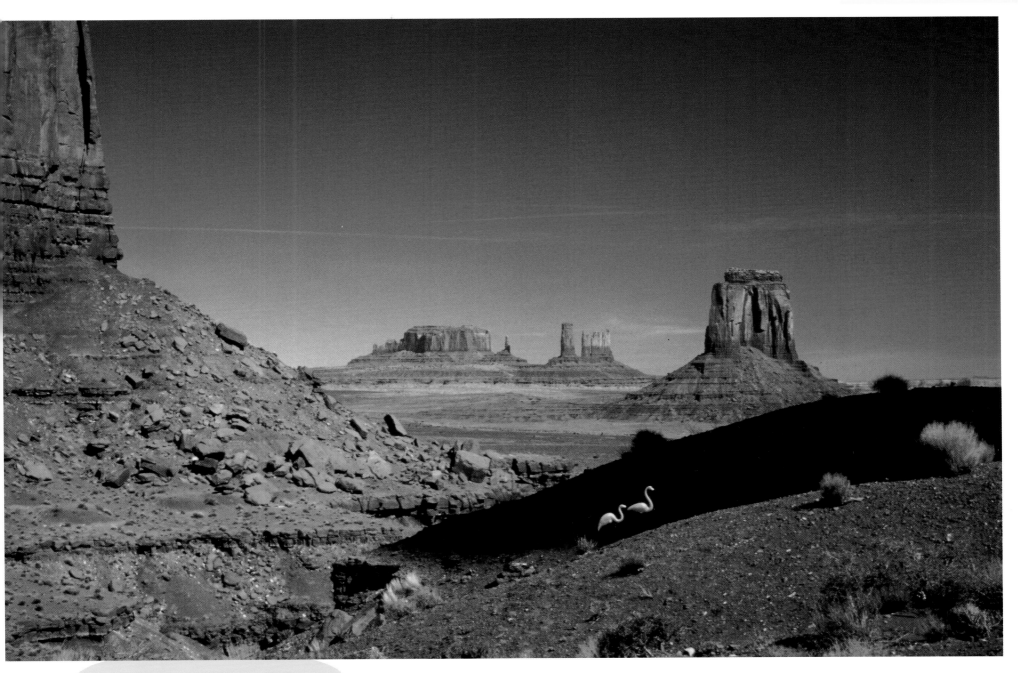

A Couple of Pink Buttes

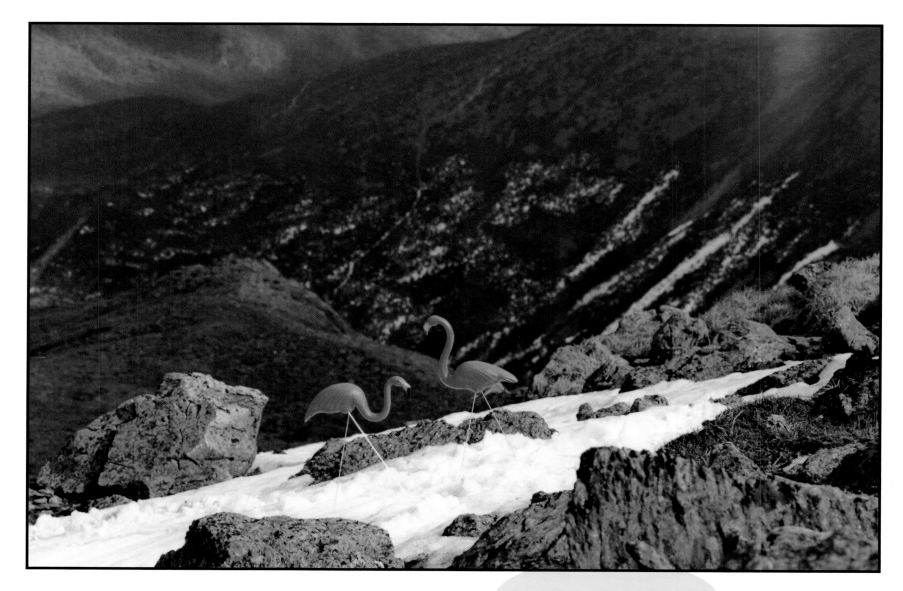

It's a Dive, Butch

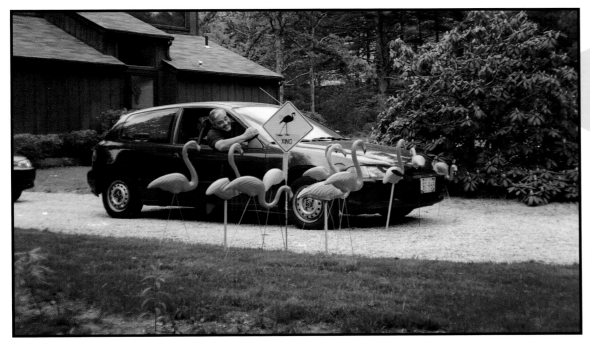

Why Did the Flamingo Cross the Road?

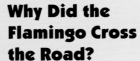

Being by nature as peaceable as the Brethren, *ruber plasticus* carried no weapons, depending entirely on their speech-making to bore miscreants into surrendering,...

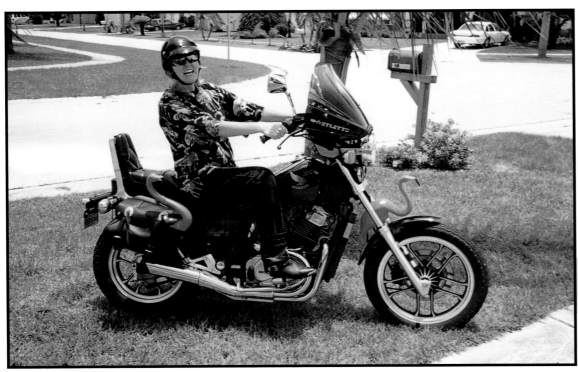

Biker Birds

"Go Nest, Young Man"

Prize Patrol

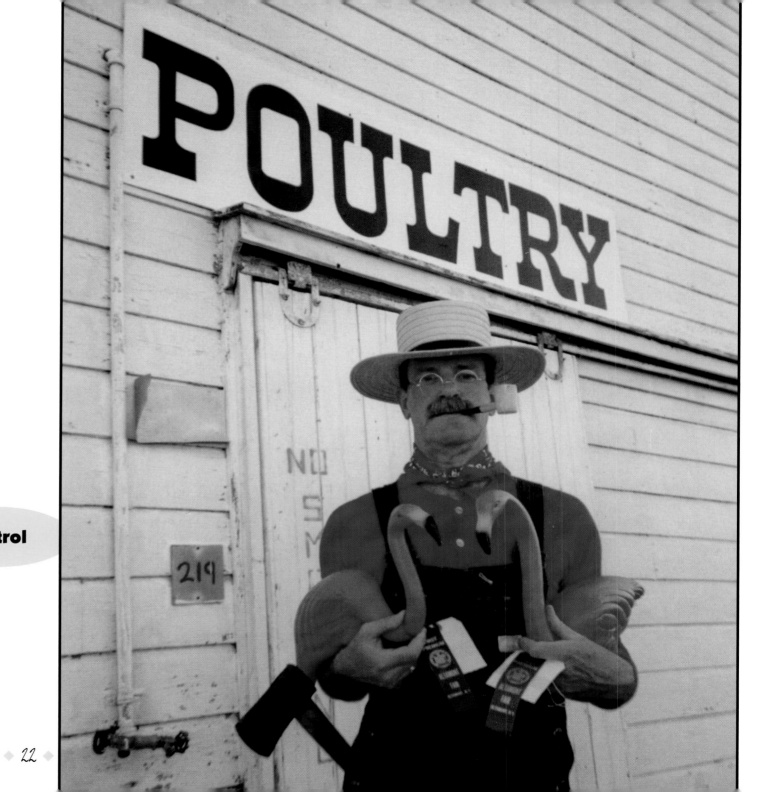

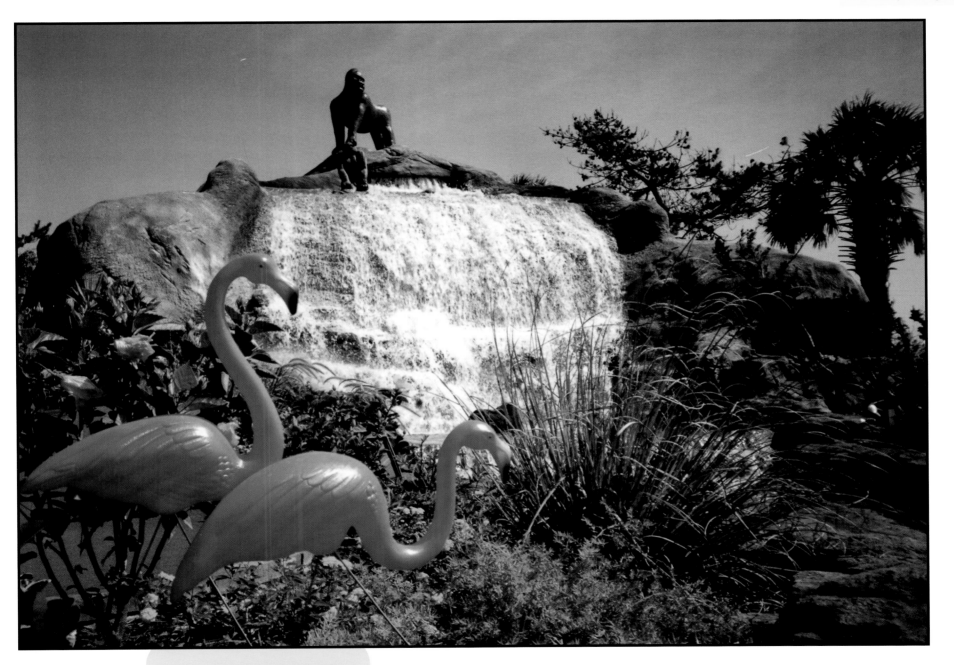

Gorilla My Dreams

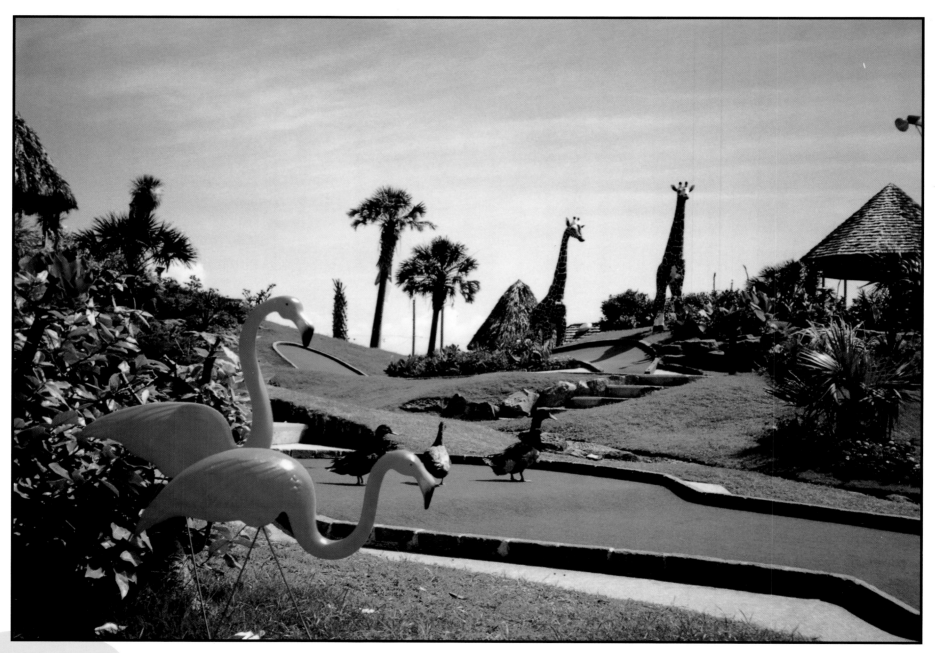

Two for Tee

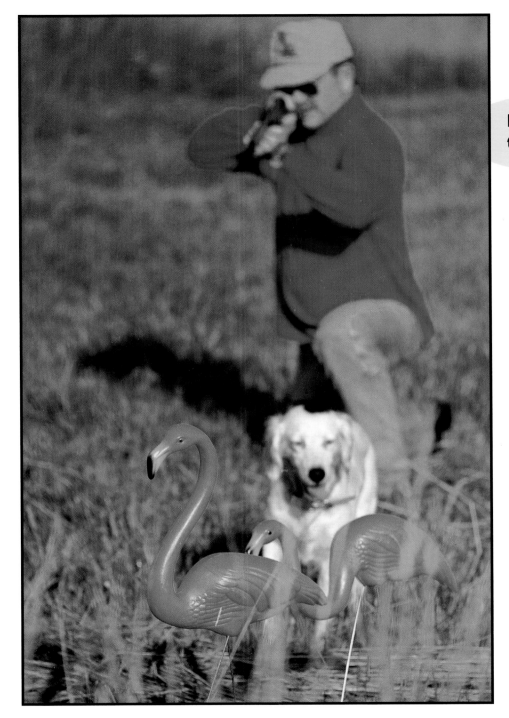

Don't Shoot
the Decoys

Lab Testing?

The pink plastic flamingoes of the West have settled into isolated communities where they can contemplate nature and work on physical fitness and channel with recycled beverage bottles.

Go Nest, Young Man

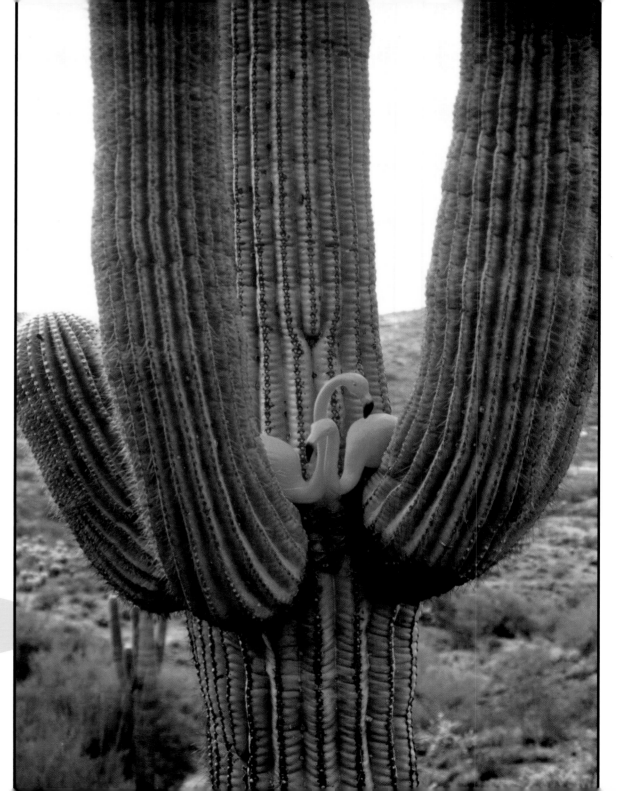

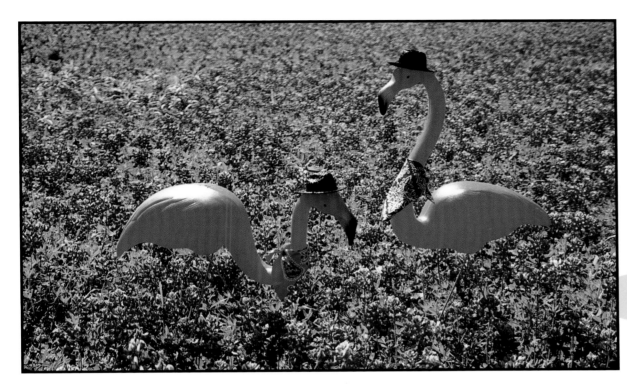

Do-Si-Do

What a Pear

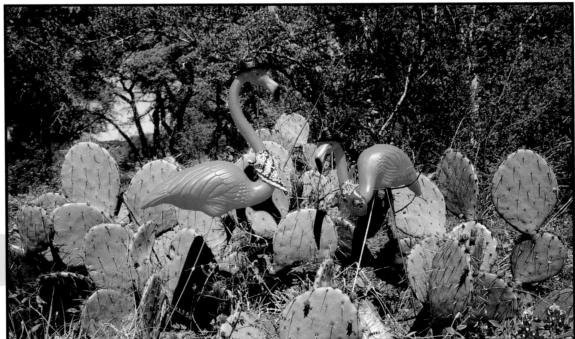

3 Party Animals

Forty years ago, zealots suggested that the color of pink plastic flamingos showed they were Commies. *Ruber plasticus* is devoted to the Party, but it has nothing to do with politics.

When it comes to party activities, plastic flamingos divide themselves into two groups.

1. The Sinister Flamingos are members of the most feared of all lawn-ornament gangs. These thugs travel in large groups and can often be found trying to peek under the petticoats of Farmer Fanny lawn cutouts. The Sinisters are tough but none too bright.

2. Garden Variety Flamingos are party throwers and party goers. They are far more likely to boogie than bug you. Miniature lampshades were made for this bunch. Their idea of a really good time is clam dip and a jug of Carlo Rossi rosé—perfectly understandable, considering their origins.

You rarely trip across a gathering of either of these groups. Since pink plastic flamingos are rather shy, they tend to freeze in traditional poses the minute human beings lay eyes on them. Only the most clever of photographers can capture their secret ceremonies. Many of the scenes you will see in this section were taken by master technicians who usually sell their work to the *Globe* and *National Enquirer*.

Readers of delicate sensibility should be warned that some of the photos in this chapter may reveal the beloved pink plastic flamingo in an entirely new light. Loitering toughs, confrontations with alien species, reckless hedonism, and wild abandon abound.

At the same time, we plead with you not to judge *phoenicopteris ruber plasticus* too harshly. Gracing Crabgrass- and Creeping Charley-infested lawns is tough work, a seven-day-a-week job. Our brightly-hued friends are denied access to Sunday services year 'round and there are few itinerant preachers who serve them. They are restrained from wildness only by their inborn sense of taste, Lawn Order (also a popular notion with human politicians), and the fact that they lack opposable thumbs.

The general run of mankind might profit from their example.

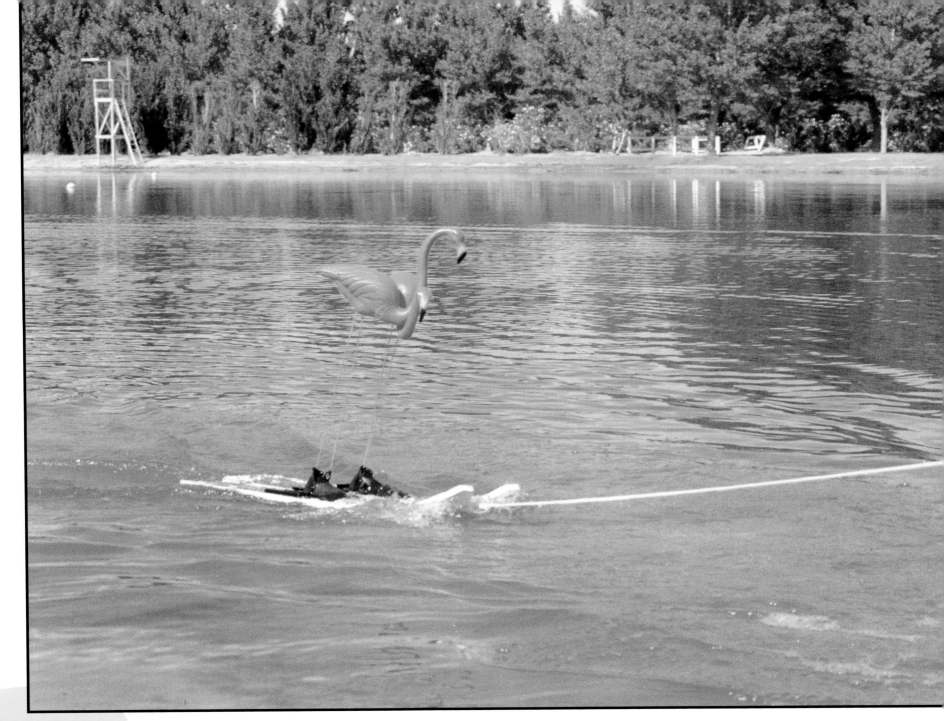

Makin' Waves

**Walkin' My Baby
Back Home**

...pink plastic flamin-
gos are rather shy,
they tend to freeze in
traditional poses the
minute human beings
lay eyes on them.

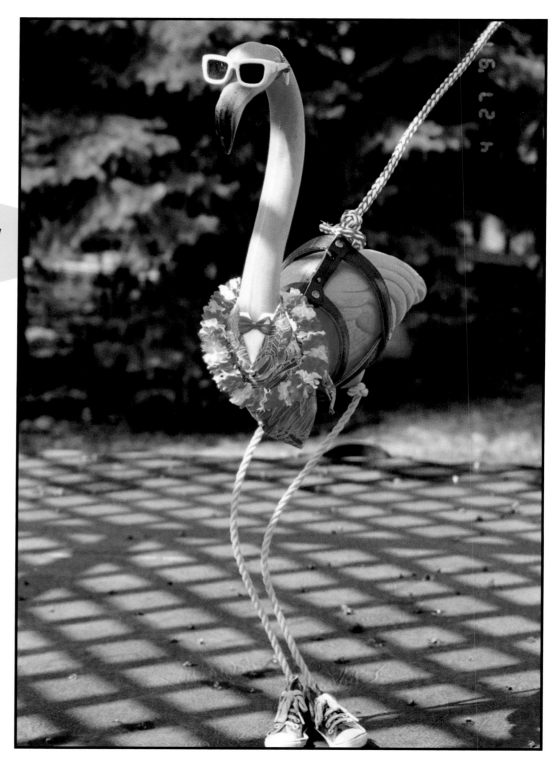

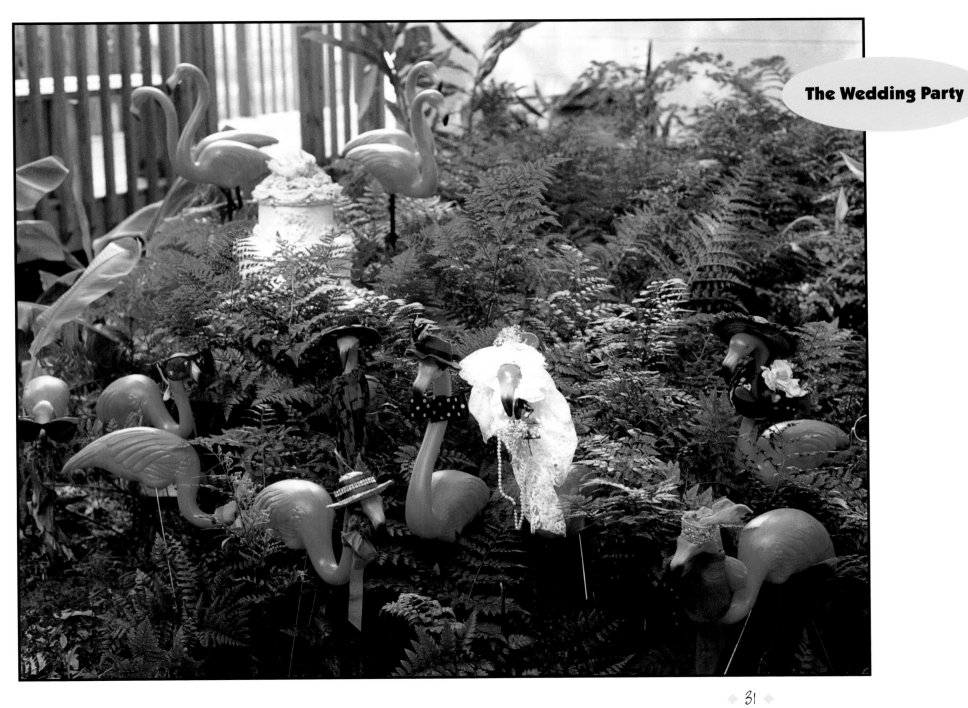

The Wedding Party

Dependent Clauses

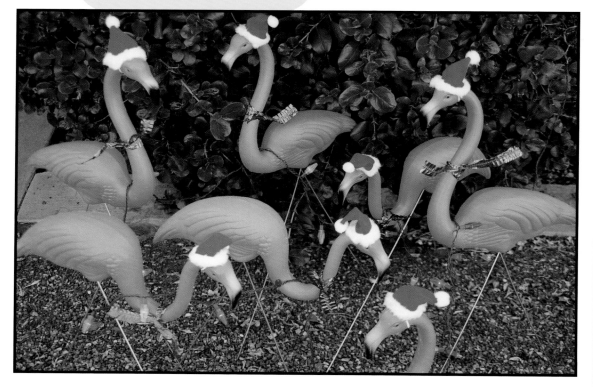

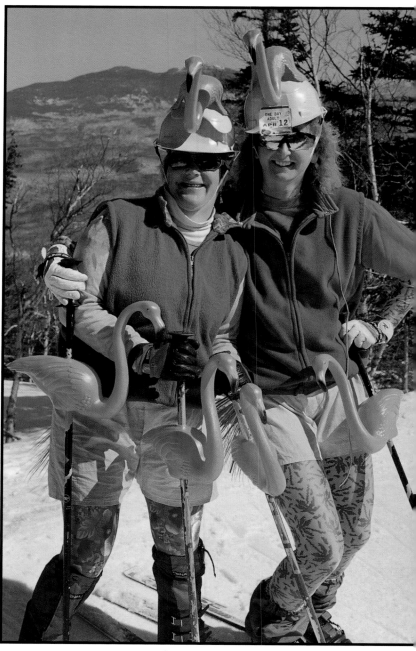

Snow Wonder

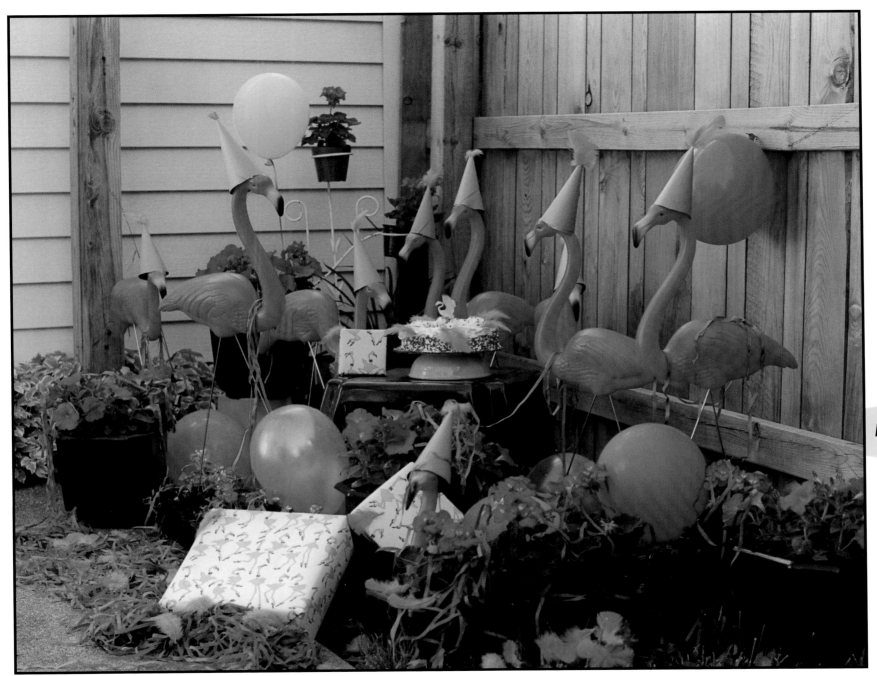

Make a Wish

Flamingo Egg?

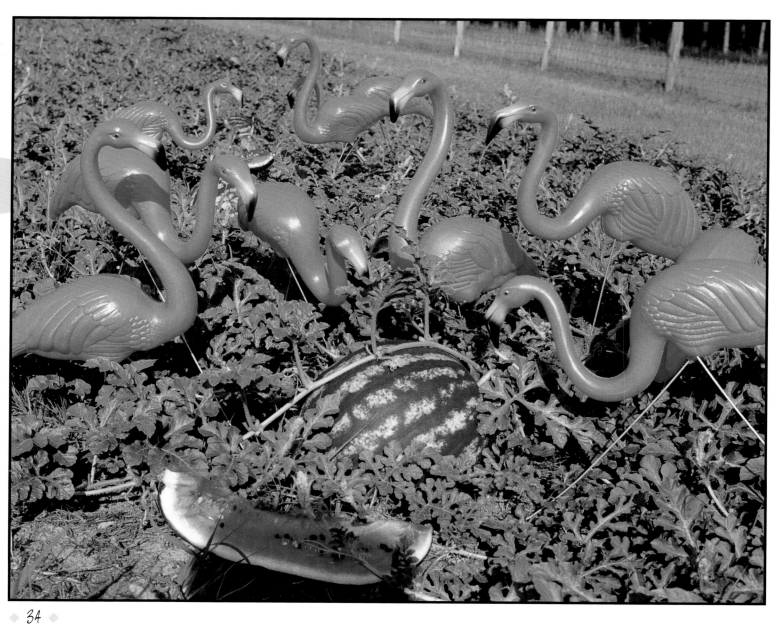

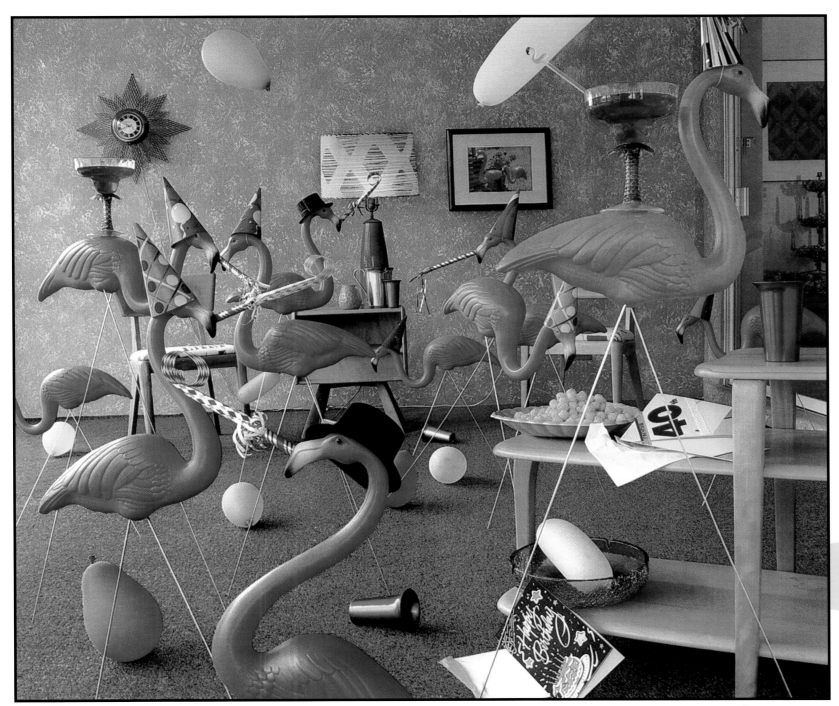

Forty and Fabulous

Flamin' Flamingo

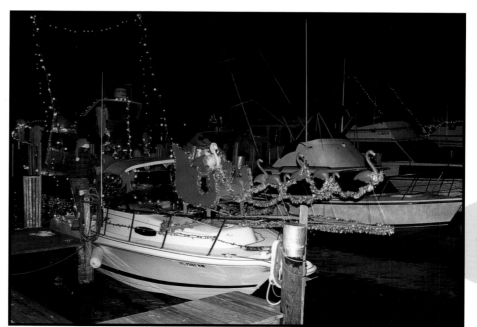

Deck the Boat with Birds of Folly

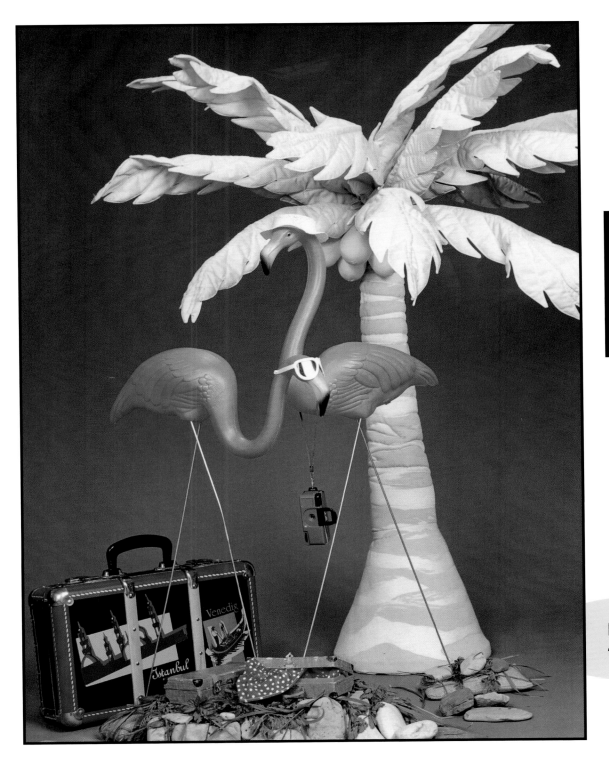

The general run of mankind might profit from their (*Ruber plasticus*) example.

Did You Remember the Sunscreen?

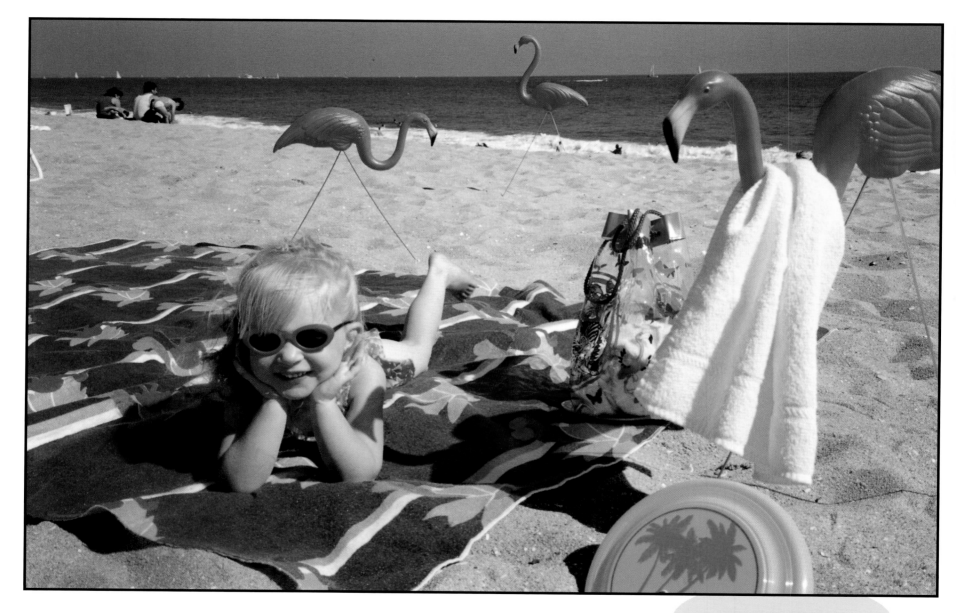

Flamingo Beach

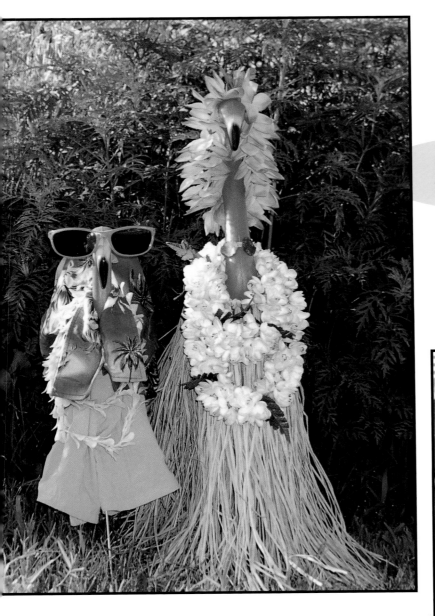

Better Lei-d than Never

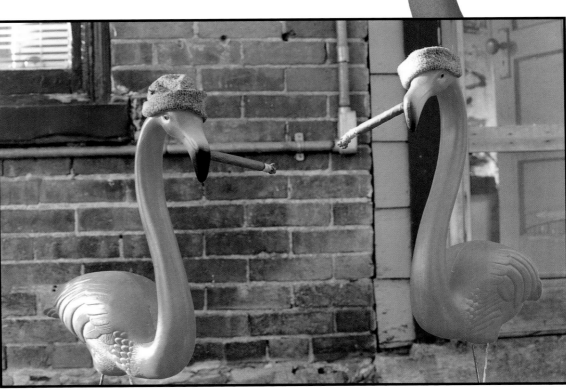

Mingos in the Hood

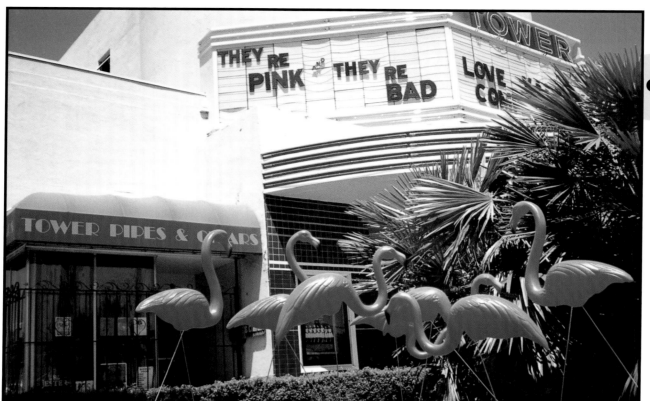

Oscar Night

On Moonlight Bay

Hen Party

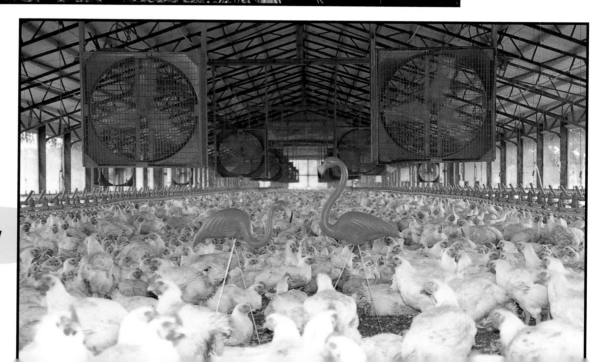

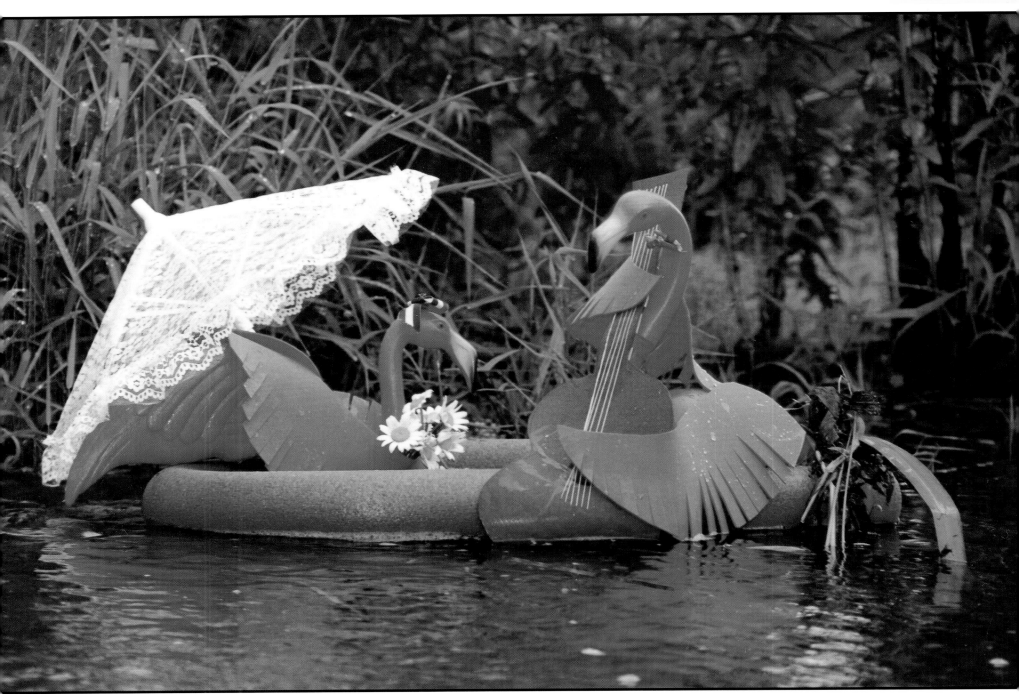

4

The American Icon

In recent years, a number of distinctly American creations have been called "cultural icons"—symbols of our values, our ambitions, and our fantasies.

Among them are the Wretched Excess Cadillacs of the 1960s, those stunning piles of chrome and soaring tailfins. The Barbie Doll, anatomically impossible, but the little girl's idea of femininity. Sandlot baseball, filled with the heroic desires of childhood and sustained by the ingenuity of sheer amateurism.

The pink plastic flamingo has joined the pantheon of American icons. It can be found in every setting, from the manicured lawns of estates to the tumbledown shacks of the poor but aspiring. It stands guard over canapes at fancy parties, serves as attendant at many more weddings than one would expect, and is counted on to make a semi-serious commentary on Life as She is lived.

One mark of an icon is that it says something about who we are. The Cadillac shouts the same message a hangover does—that the road of excess leads to the palace of wisdom. Barbie speaks of American ideals of feminism and beauty, possessions and romance. The kids' game of baseball says we can all be heroes or goats, that a fancy glove and a brand new ball don't make the game.

Once, *phoenicopteris rubis plasticus* was thought to own but one word in the American vocabulary: tacky. Over the last 40 years, Don Featherstone's inspired lawn ornament has begun to speak a different language. This Splendor on the

Backyard Gothic

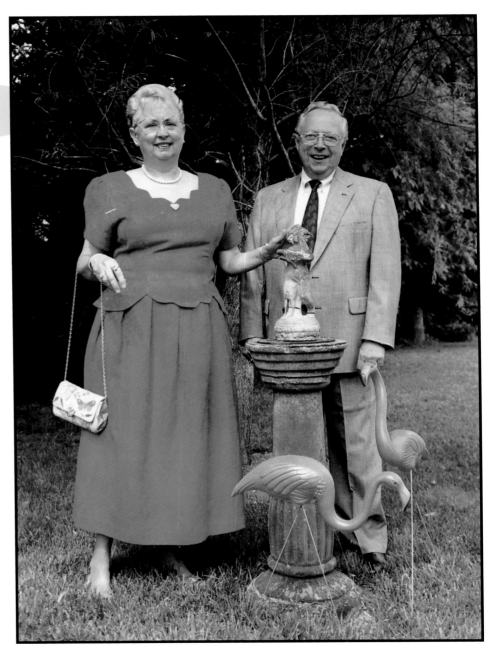

Grass says volumes about our ability to smile at ourselves, to not take matters too seriously.

Oh, sure, there are Freudian psychologists who have suggested that pink plastic flamingos are little more than a delusion. They pretend a flamingo is at heart nothing but a stork with a severe rash. They say the stork is the legendary bringer of children, so our affection for *ruber plasticus* has a lot to do with our childhood and the suspicion that the people we thought were our parents were really just caretakers and that we appeared at their door in the beak of a large, gawky bird. Even those of us who actually were delivered by a stork know this is rubbish.

What the pink plastic flamingo *is* is a little fragment of our own character—the ability to be silly, a weariness with conventional notions of taste and beauty.

Phoenicopteris ruber plasticus is as American as cranberry/apple pie, stick deodorant, squirrel's tails on car radio antennas, Odor Eaters, and the Internal Revenue Service. It is a genuine icon and the source of delightful fancies.

Jingoists keep shouting that we need to celebrate America's greatness. They insist that life is serious and should be dealt with sternly and soberly. The pink plastic flamingo reminds us that life can also be fun, that we should delight in the small things. It seductively whispers that Americans need to acknowledge and indulge in their triviality if they really want to be great.

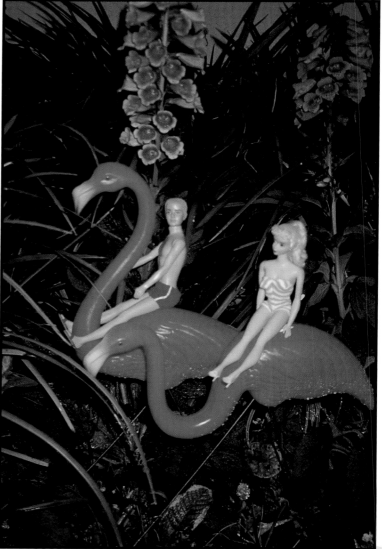

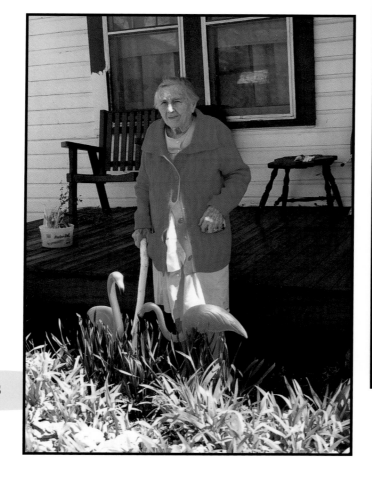

Friends

How Do You Adjust This Seat?

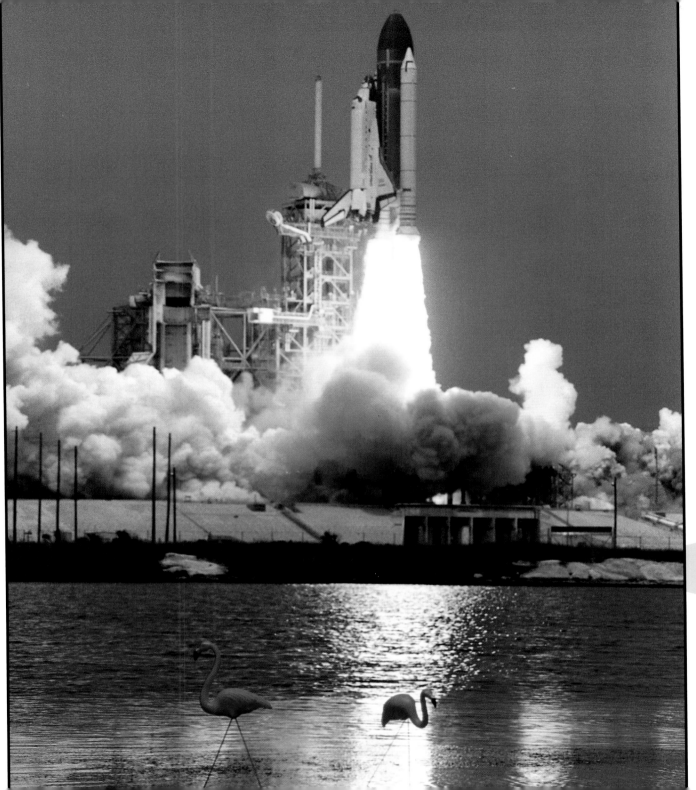

Nerves of Steel

A Double Ceremony

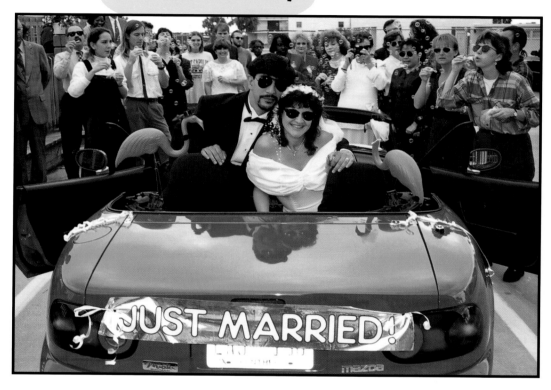

Perfect Attendants

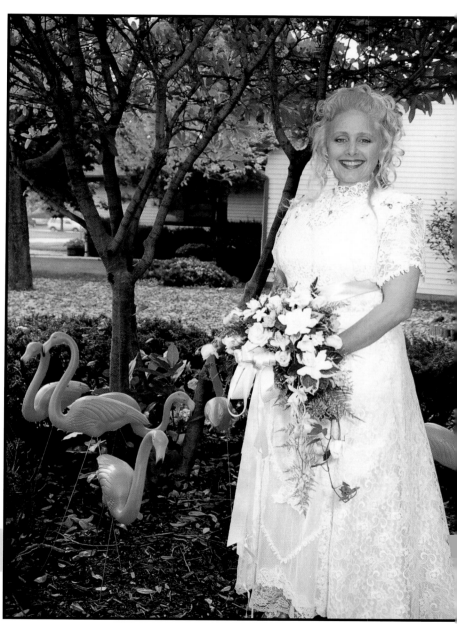

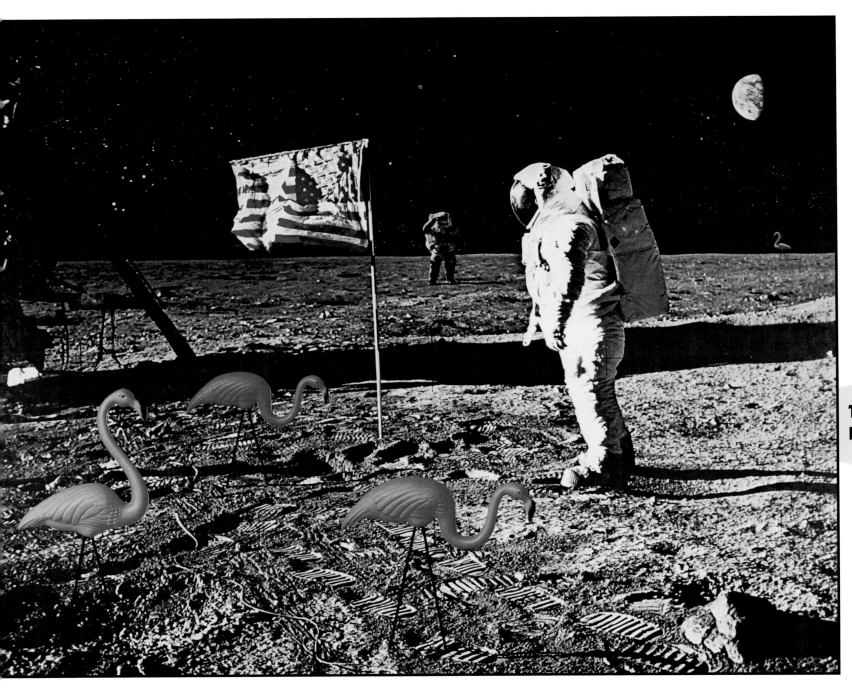

There Goes the
Neighborhood

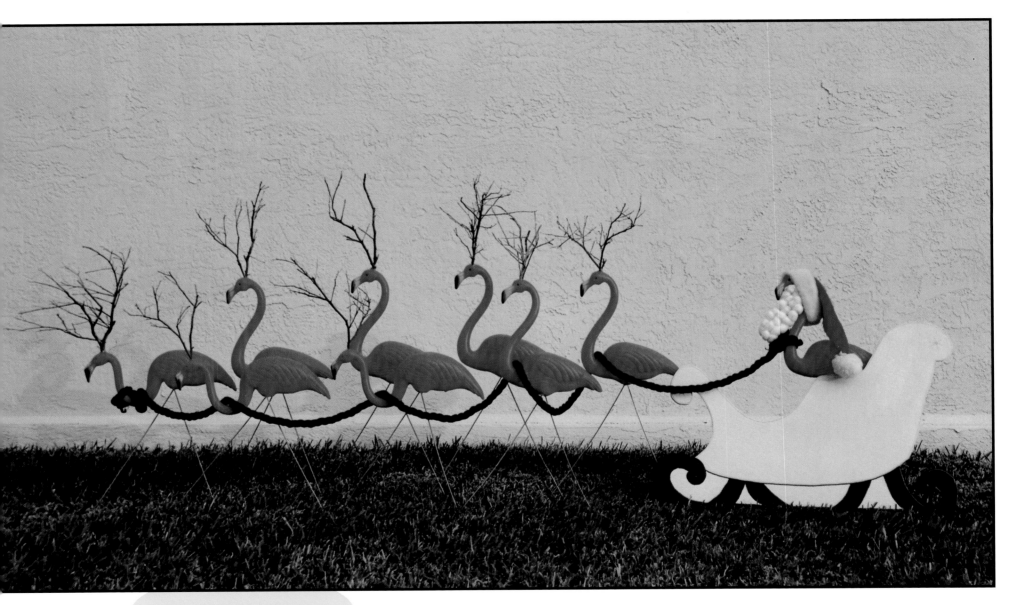

This Will Sleigh You

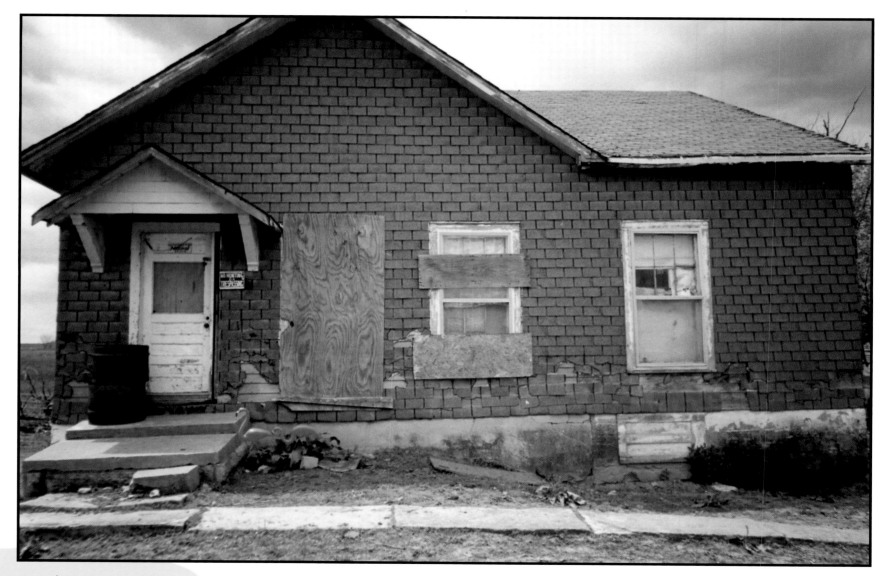

Location, Location, Location

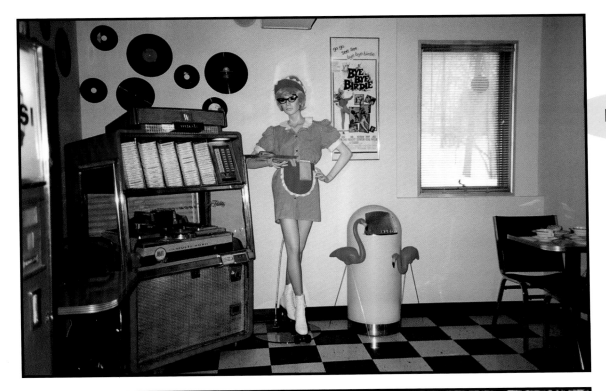

Nifty-Fifties

Phoenicopteris ruber plasticus is as American as cranberry/apple pie, stick deodorant, squirrel's tails on car radio antennas, Odor Eaters, and the Internal Revenue Service.

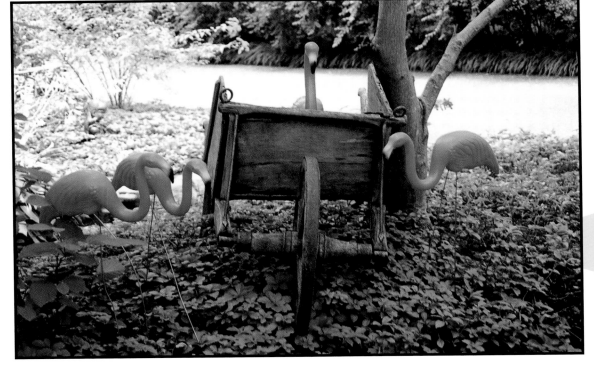

Wheelbarrow Race, Anyone?

Out of This World

So Pick It Up!

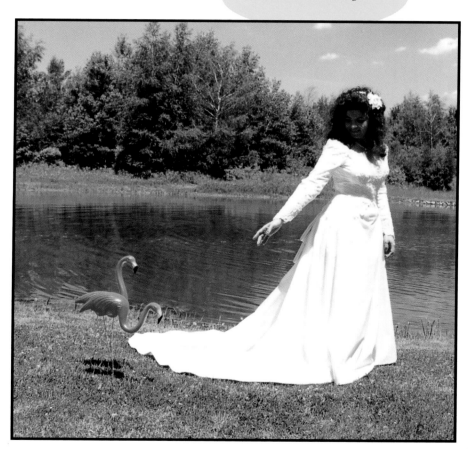

Where's the Shrimp?

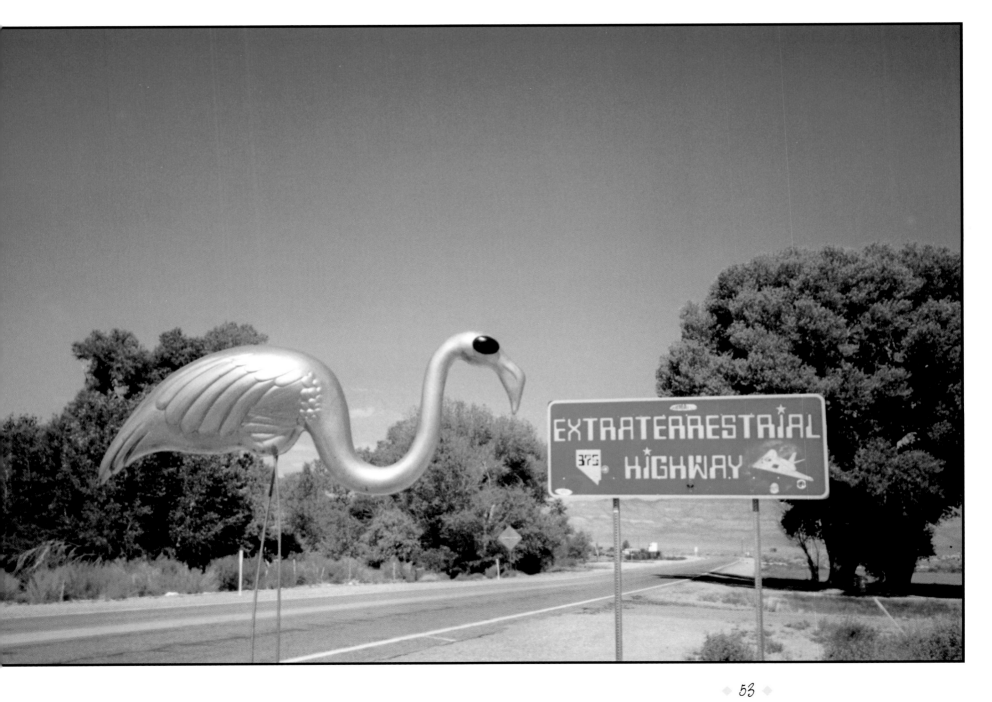

5

Phoenicopteris as Sort-of Sex Object, or, Pretty in Pink

Snobbish galoots turn up their noses at the notion that anyone could possibly see the pink plastic flamingo as beautiful. These devotees of microbrews, whole grain breads, and faux leather patches on the elbows of their Harris tweed jackets argue that *phoenicopteris ruber plasticus* is "artificial." Such are the shortcomings of modern education and common sense.

Face it, people, pink is beautiful. And fans of the flamingo aren't afraid to admit it.

For the historically as well as aesthetically challenged, the siren song of the blushing color goes back thousands of years, perhaps to Homer, whose references to *rhododaktulos eos*—"rosy-fingered dawn"—may be the most common phrase in both his *Iliad* and *Odyssey*. And our own culture can find few higher compliments than to say someone is "in the pink" or more sincere praises than for the "ruddy-limbed youth" of song and poem. Nowadays, *pink* has overwhelming implications of delicacy and, in fact, it originally comes from a Dutch word meaning "little" (that's why your little finger is called a "pinkie," but I digress). To most people, the color pink connotes health, heartiness, femininity and—face it—a fey loveliness. Yet our beloved flamingo mixes passion with beauty, for its very name is derived from that most dramatic of Spanish dances, the flamenco.

Even those of us who had considerable difficulty figuring out which end of the frog to stick the scalpel with in his high school biology course (not to mention which end of the scalpel to grasp) realize that not *all* plastic flamingos can be feminine, and Featherstone's Law assumes that one of every pair is of the opposite sexual persuasion but that no one can tell which. As noted in the introduction, *phoenicopteris*, like the angels (we assume), is wholly without external indicators of gender. Thus, affection for either (or both) of the pink plastic flamingos in a pair—or all of them in an undifferentiated flock—offends neither the laws of man nor the alleged dictates of the seraphim.

No matter your affiliation, no matter your taste, the pictures which follow will leave no doubt that fraternal and

sororal passion for the beauty of *phoenicopteris* is limited not by geography, nor class, nor age, nor income. Though here the pink plastic flamingo is occasionally caught in its most familiar habitat, the manicured Kentucky Bluegrass lawn, more often he (or she) is surprised wading beside some bosky fen or delicately a-tiptoe in a lonely glade. Be assured: these poses among the rarified splendors of Mother Nature are not chosen to grant beauty by association to the beloved flamingo but to allow our ruby-hued friend to call attention to the otherwise sterile charms of the world we live amidst.

None of this is to suggest, of course, that the pink plastic flamingo seeks no higher role in life than to touch our spirits and raise our hearts. Whether bearing the mundane task of pinning down a landscaping scheme or providing a patient subject for someone's glassy gazing ball, *phoenicopteris* carries out the role without complaint or embarrassment. What we see in this humble ornament is no mere ornamentation; in the pink plastic flamingo we perceive a simple beauty of Soul, even a willingness to be defiled to serve a higher end. An October 12, 1997, Associated Press announcement, for instance, revealed that the South Florida Water Management District was planning to paint pink plastic flamingos *white* and to use them as decoys for egrets because the flamingos "are cheaper than the more realistic plastic egrets that can be bought on the decoy market." Despite the fact that the physical similarities between the two species are minimal (in fact, egret decoys have but one leg, owning to the fact that the actual bird is inclined to stand on a single appendage so it can tuck up its other foot to keep it warm), the plastic flamingo will apparently be subjected to this indignity and violation of its beauty in support of sheer bureaucratic cheapness. Yet beneath that tacky coat of white paint will still lie the beauty of America's Darling.

...always pretty in pink.

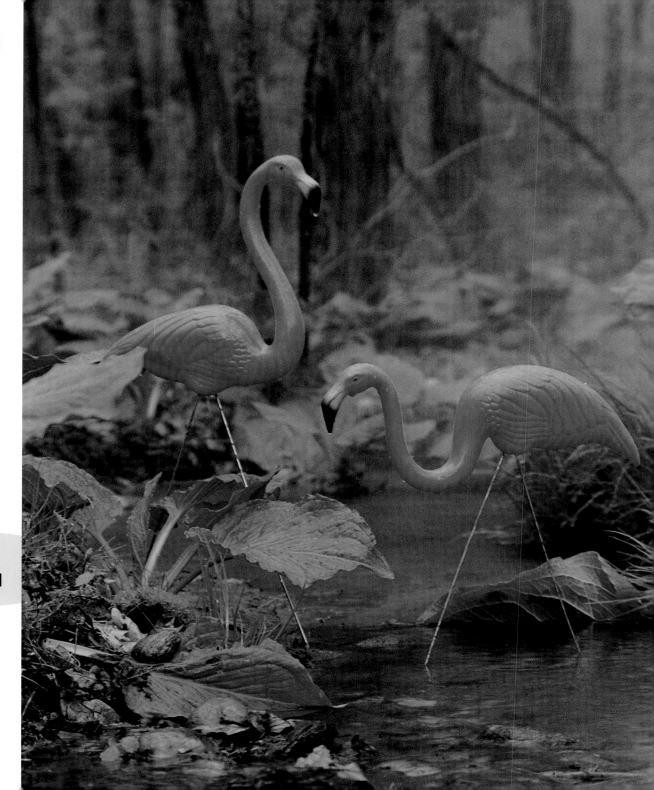

**Woodland
Wonderland**

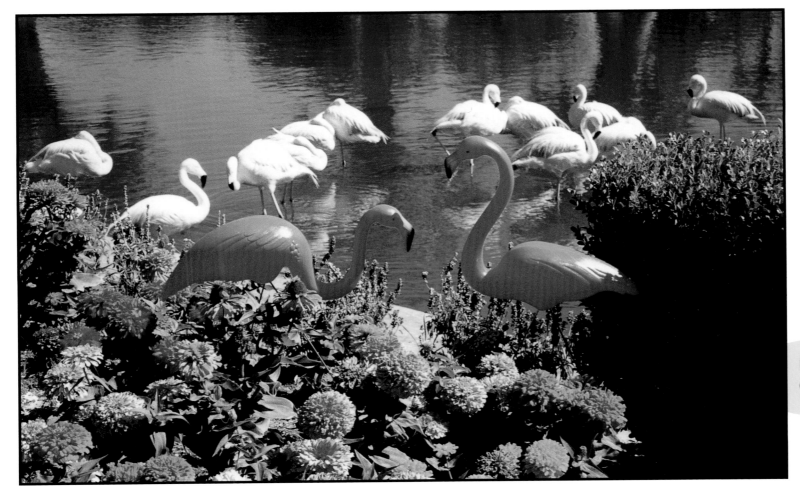

Pale By Comparison

On Pinkish Pond

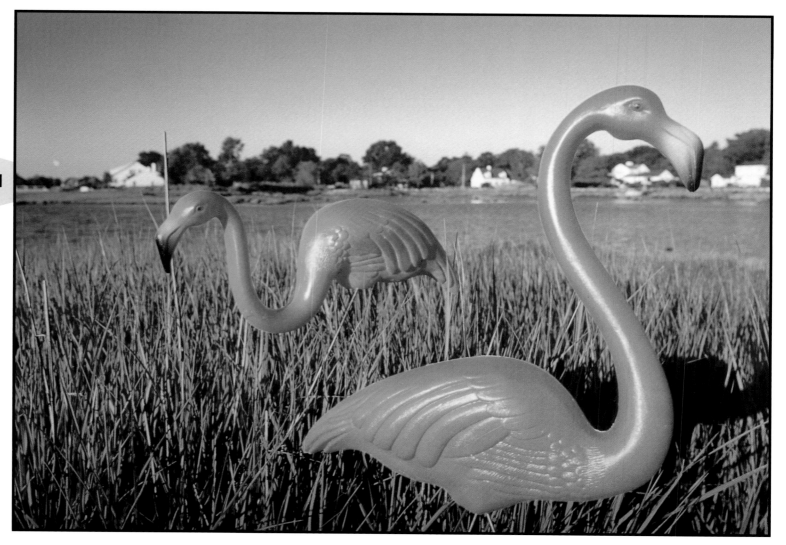

...in the pink plastic flamingo we perceive a simple beauty of Soul, even a willingness to be defiled to serve a higher end.

Pretty in Pink

Pool Parlor

Pussy-Footing Around

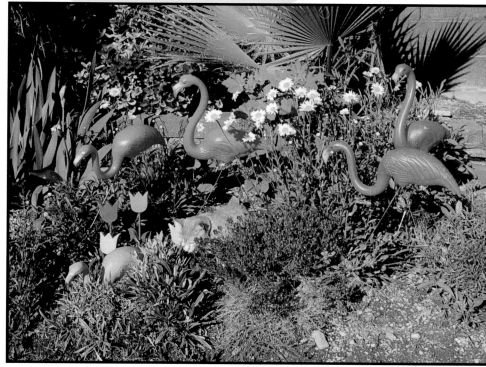

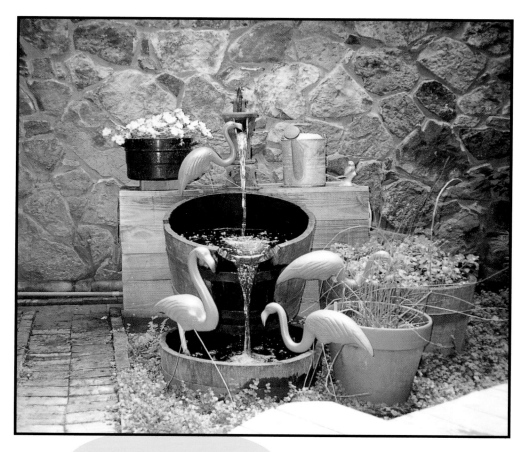

Pink Lemonade

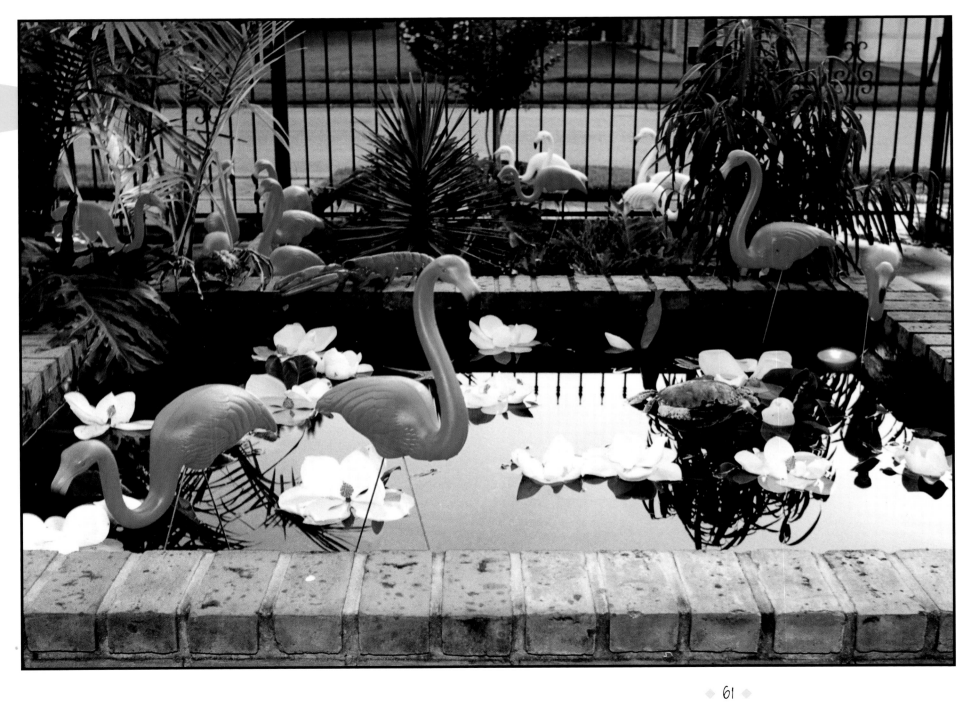

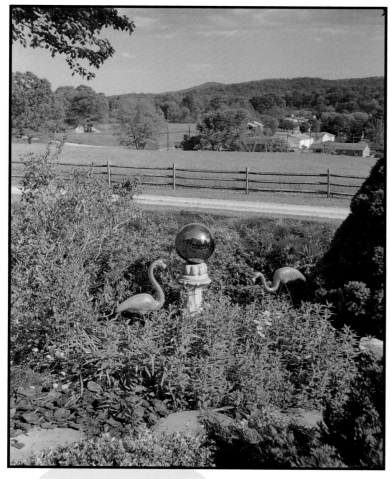

Grazing Ball

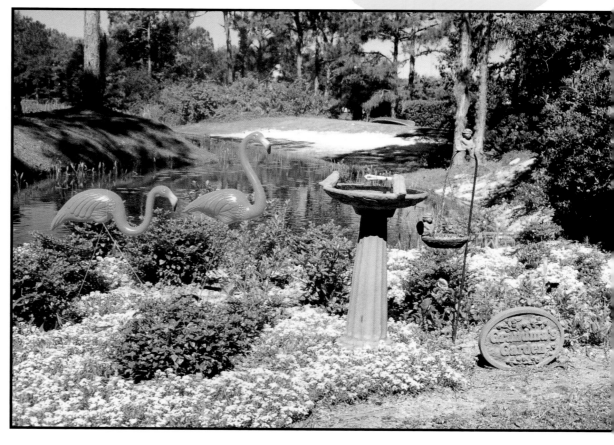

Grandma's Garden

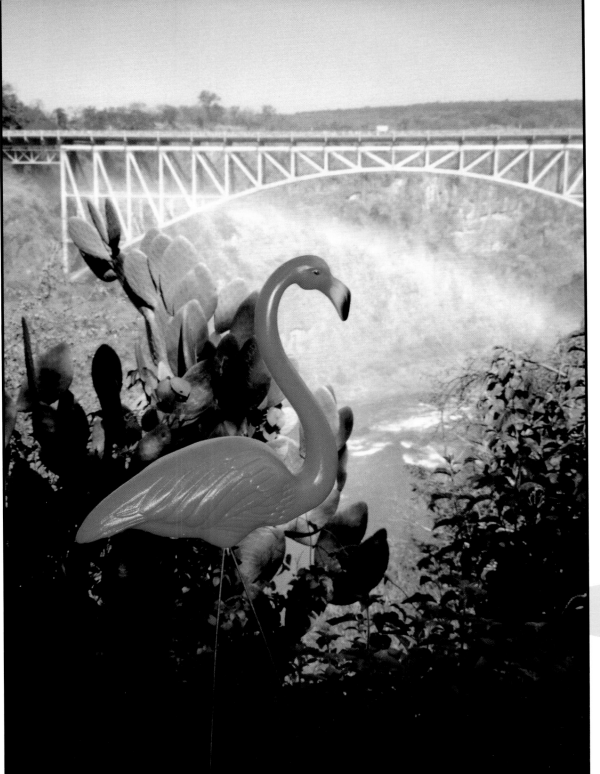

Anyone for Bridge?

American Standard

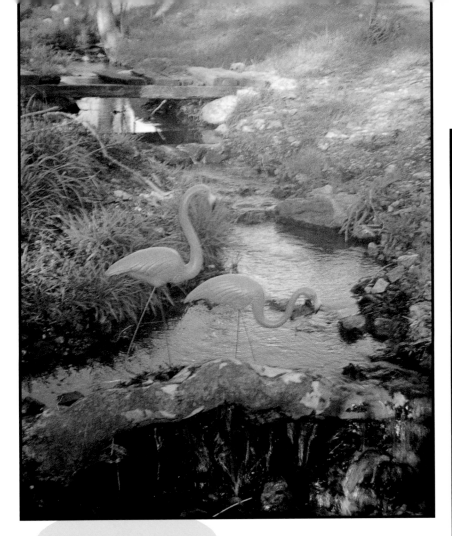

Watch Your Step!

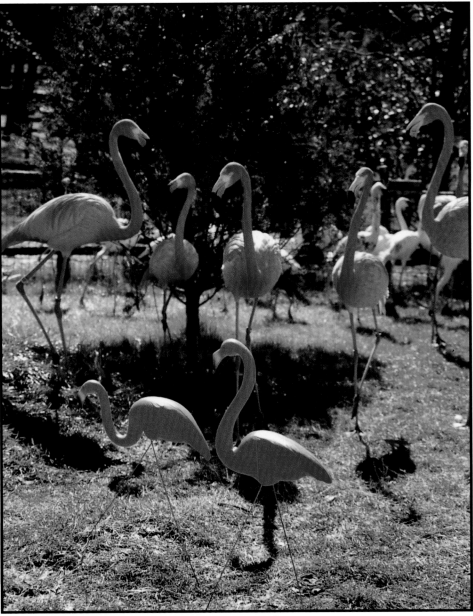

New Kids on the Grass

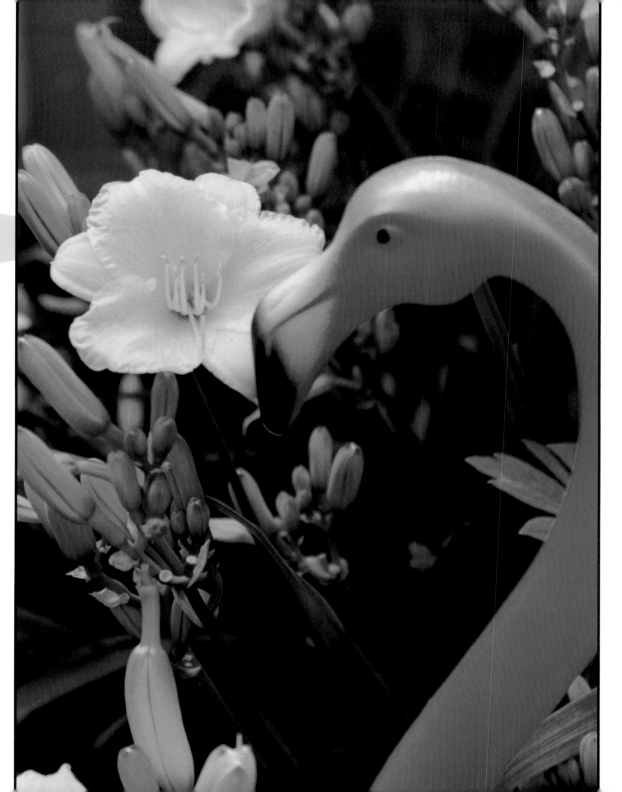

Flamingo in Bloom

For the historically as well as aesthetically challenged, the siren song of the blushing color goes back thousands of years, perhaps to Homer...

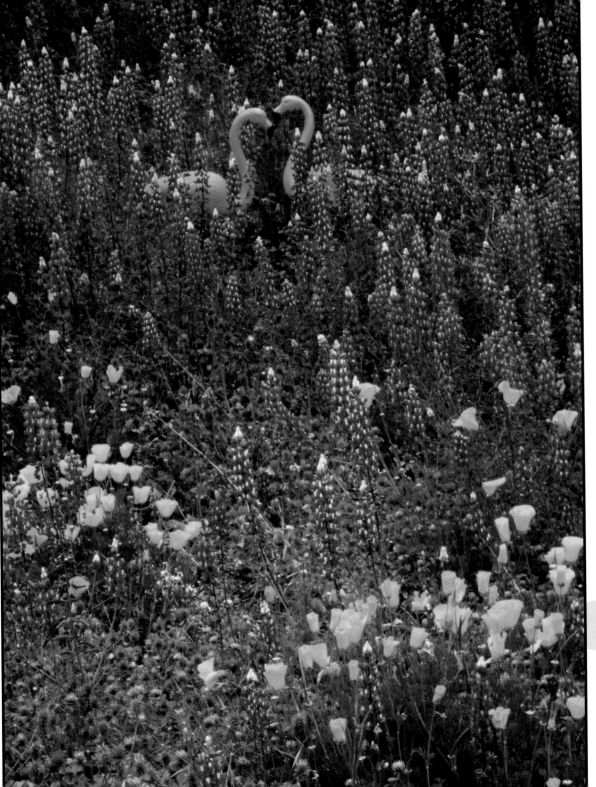

Purple Passion

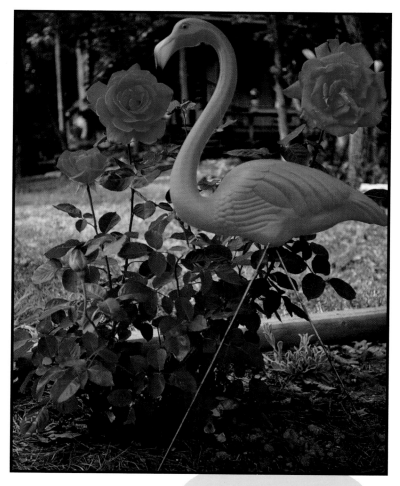

A Rose By Any Other Name

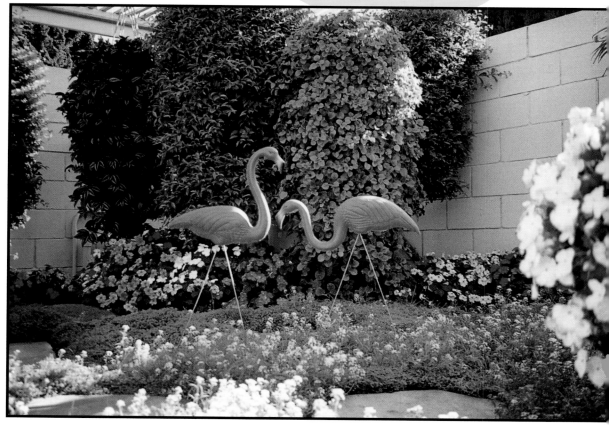

The Garden of Eating

Martha Mingo and the Vision of Beauty

Just as mankind crawled forth from the seas, learned to breathe the air of New Jersey, and formed itself into CPAs, professional wrestlers, and political candidates, the pink plastic flamingo has evolved.

Thirty, even twenty, years ago, the pink plastic flamingo was considered tasteless. But when a former fashion model transformed herself into America's dramatic doyen of domestic design, it became very clear that beauty (and the ridiculous) was mostly in the eye, kitchen, and potting shed of the beholder. If there had been no Martha Mingo, the Brother/Sisterhood of flamingos would have had to invent her for fear that *pink*, *plastic*, and *louche* would become synonyms, at least for crossword buffs and those few souls who spend their solitary hours reading the *Oxford Dictionary of the English Language*.

But Martha Mingo exists as really and honestly as the former fashion model and has solidly shaped the use of pink plastic flamingos to fulfill what she calls her "Vision of Beauty," from which I quote:

◆ *"Flamingi flame:* In its youth, the flamingo is rosacious and needs its lively colors offset by vigorous hues.

◆ *"Flamingi fade:* In its maturity, the flamingo becomes subtle and can develop a rich patina. It is then best to treat it as object qua object and place it with things of equally interesting form and structure.

◆ *"Flamingi fidelis:* The flamingo is faithful to its time and place. No juxtaposition of a flamingo and another object is out of place."

The influence of Martha's philosophy is evident in many parts of this visual treatise, with apt counterbalances of forms and shapes, colors, allusions to classical and contemporary art movements, and even the occasional appeal to our sense of whimsy.

But this section shows the lengths (and, some would say, the depths) to which plastic flamingo lovers have gone to create a parallel universe where no man has gone before (at least while conscious and reasonably sober). Old standards have been gently nudged aside to test the limits of the "Vision of Beauty." The boundaries of evolution have been tested. Alternate realities have been allowed to cascade across the breadth of this mighty nation, and Martha Mingo is as much the foremother of this revolution as her much more famous and, inevitably, much wealthier human counterpart in the struggle to make America the Land of the Tasteful as well as the free.

As one sociologist has written, "perforce, in the unsubstantial culture which surrounds each and every one of us every day, little more can be thought of as a truth than that the pinkness and plasticness of a rubicund entity in the midst of a confounding and stultifying society speaks volumes."

To which all of us can gratefully say only one thing: "Amen, brothers, amen."

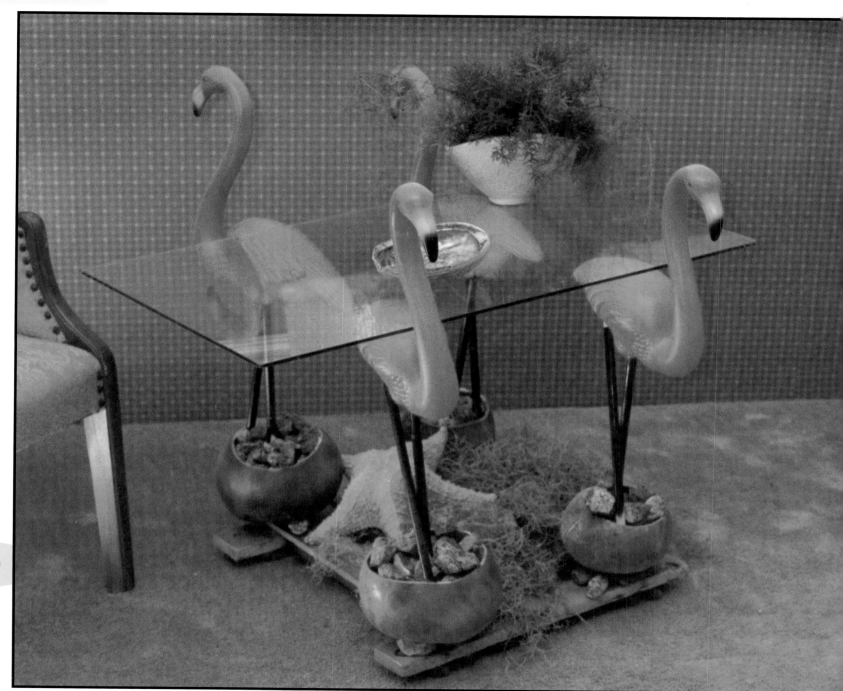

Duncan Mingo

50s Kitch-en

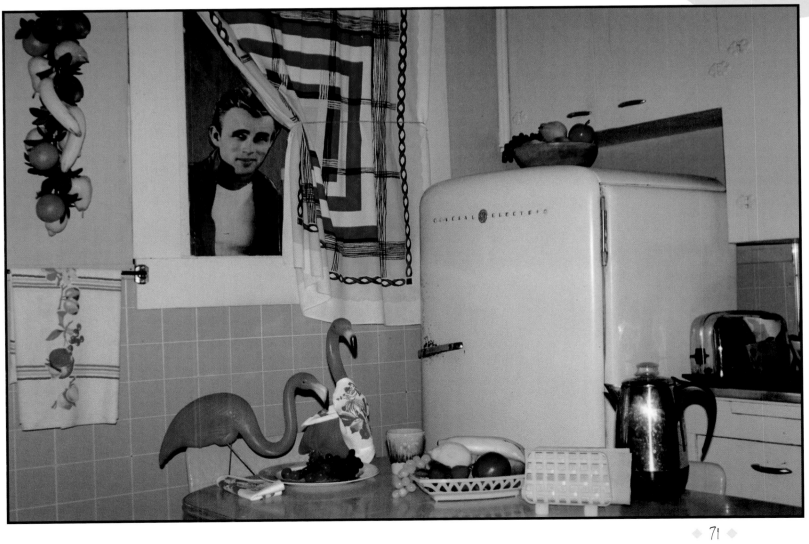

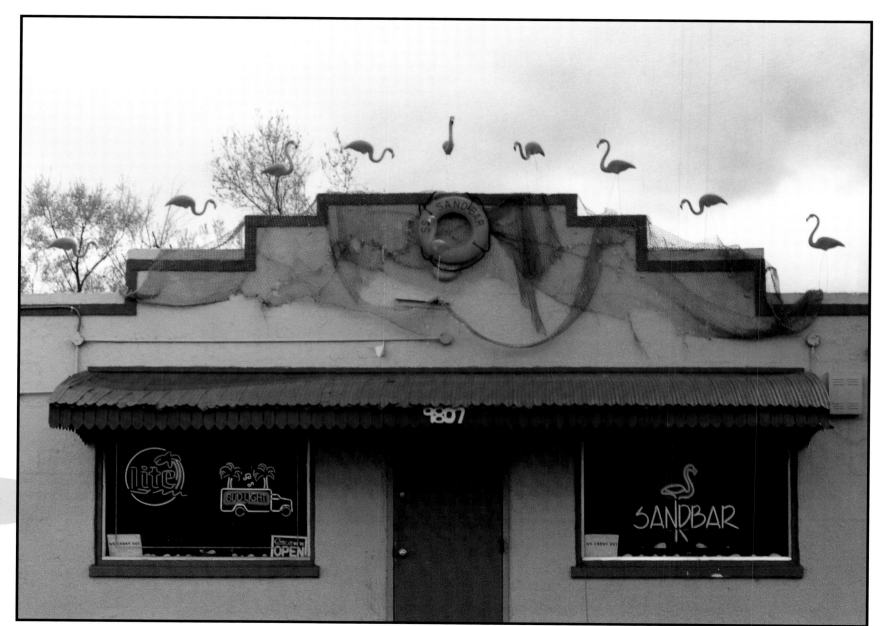

Bar None

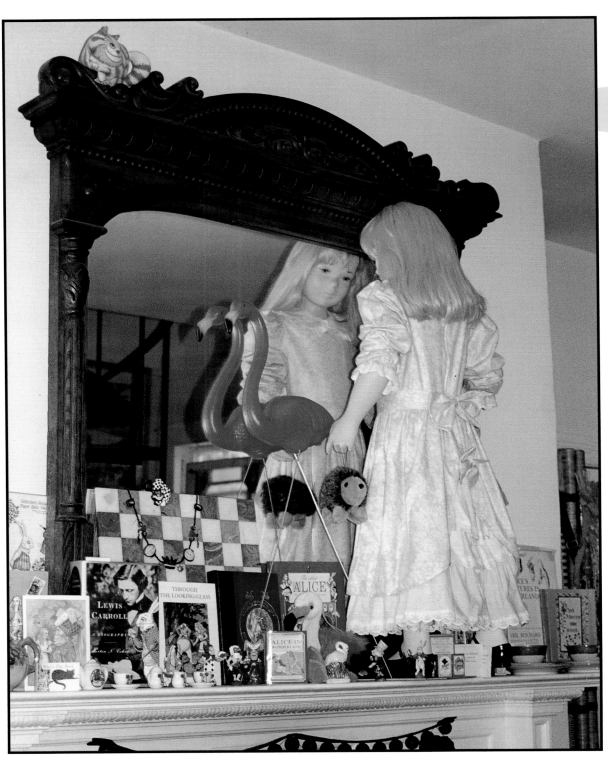

Mirror, Mirror

...perforce, in the un-substantial culture which surrounds each and every one of us every day, little more can be thought of as a truth than that the pinkness and plasticness of a rubicund entity in the midst of a confounding and stultifying society speaks volumes.

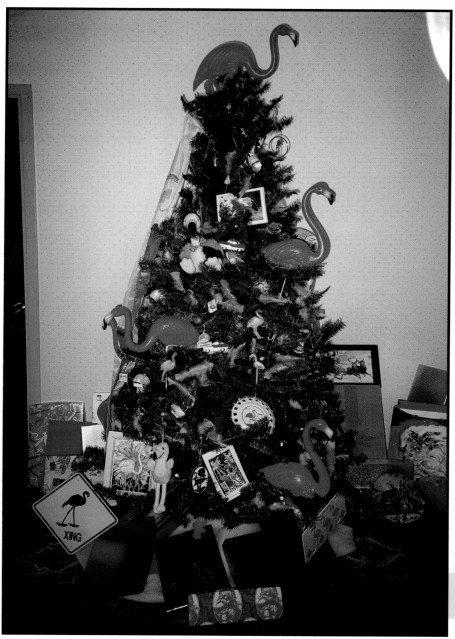

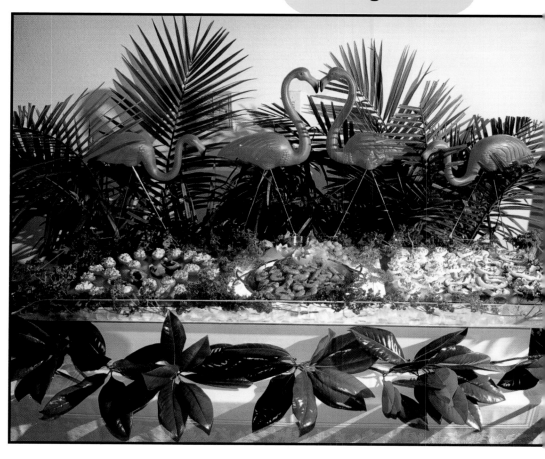

Flamingo Feast

Merry Mingos

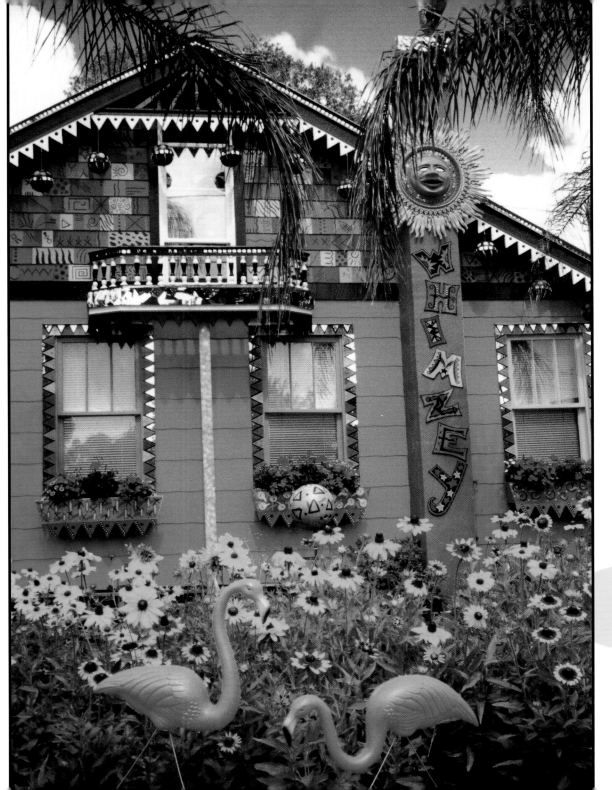

And They Think We're Tacky!

Flamingo Family Tree

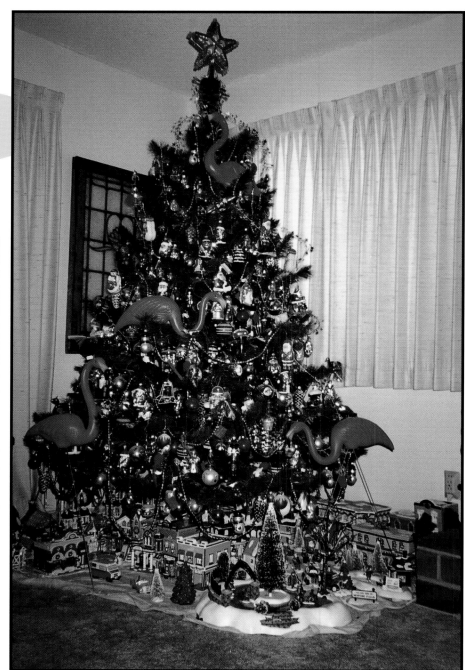

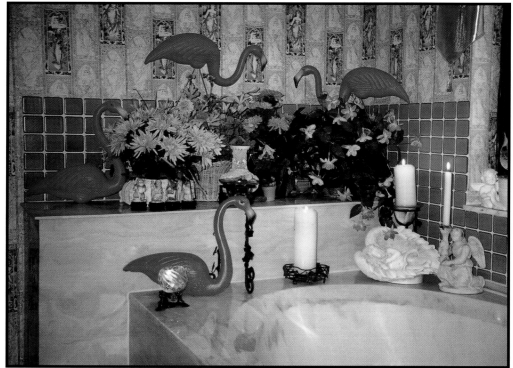

Amazing Grace

You Can't Be a Blues Brother Without Being in the Pink

Almost since the beginning of organized time (that is, ever since man has been able to read the clock) scientists have been working to fit the things of the world in neat categories.

All of us remember high school science courses, with their genera, phyla, and other things that made us fail weekly quizzes. Scientists won't admit it, but there are some things that are so uniquely themselves that they don't fit any category except "other."

Which is where we find ourselves at the end of this patient examination of *phoenicopteris ruber plasticus* in all his/her manifestations. Somewhere in this country is a small subcult of apparently human beings who see reality in a fashion none of us can imitate. Their sense of the ridiculous is so finely honed, their access to alternate realities so sophisticated, that all we can do is sit back in awe of The Other, a tiny cliché lately made popular by *X Files* fans, though occasionally used by persons of stature almost equal to Agent Mulder's—St. Paul, St. Augustine, Jesse Ventura, and Rene Descartes amongst them.

No matter how great a curiosity the pink plastic flamingo becomes, he never loses his "essence," as Aristotle would say. By his patience amongst foreign surroundings, he sends forth the most important message of all—to quote another contemporary philosopher, Popeye—"I yam what I yam."

It's a message we could all learn from.

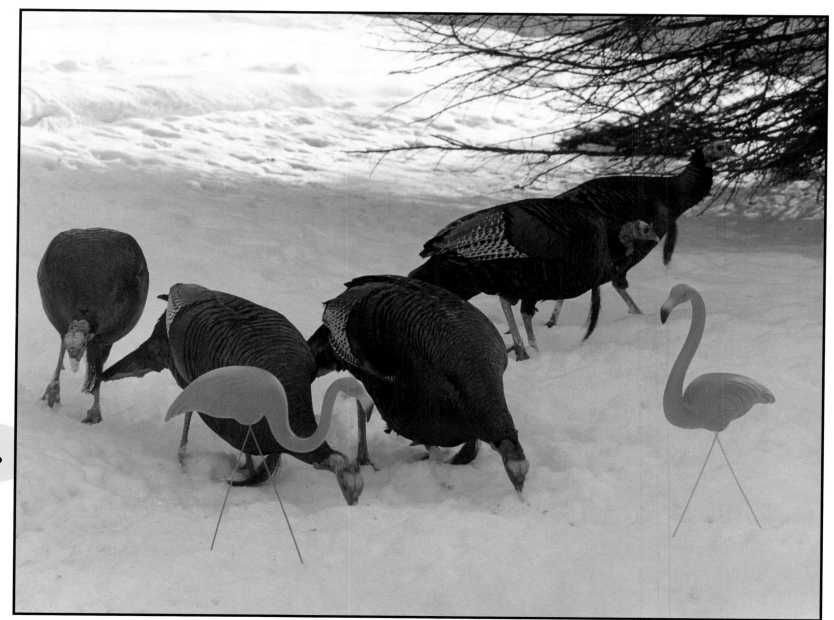

**Who Invited
These Turkeys?**

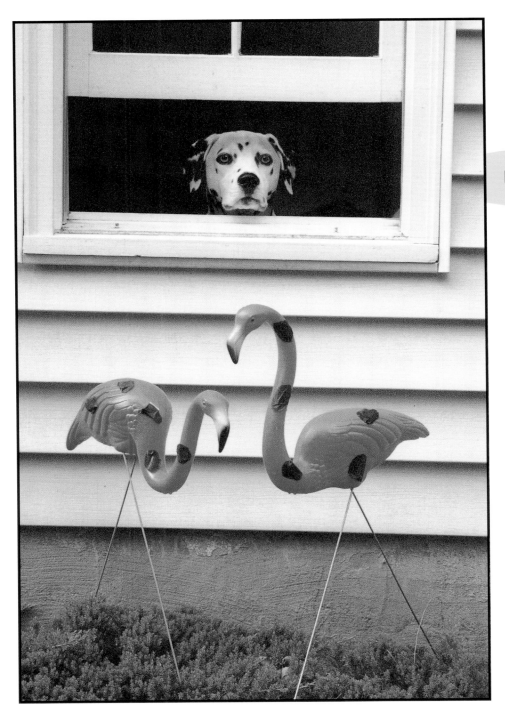

I Think I Spotted One

By the pink plastic flamingo's patience amongst foreign surroundings, he sends forth the most important message of all..."I yam what I yam."

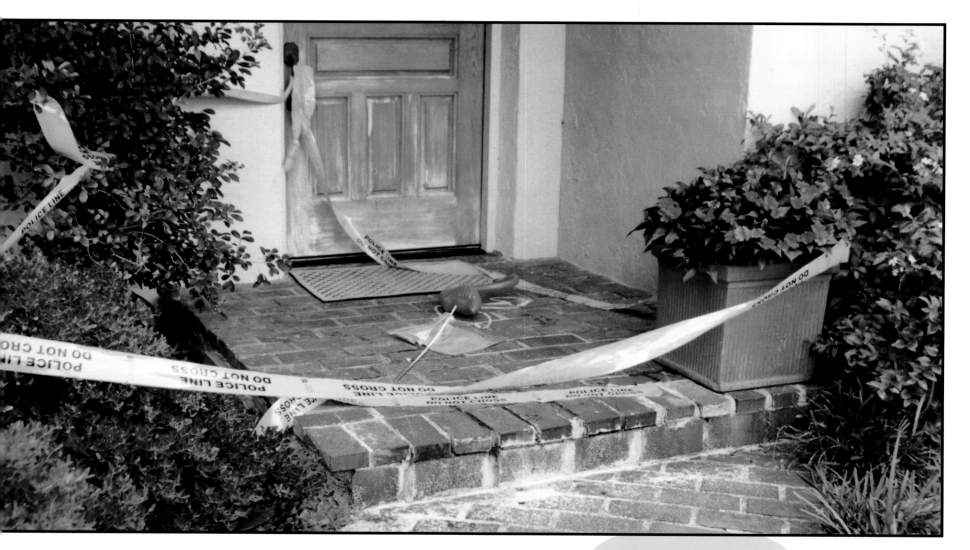

The Butler Did It

What's This?

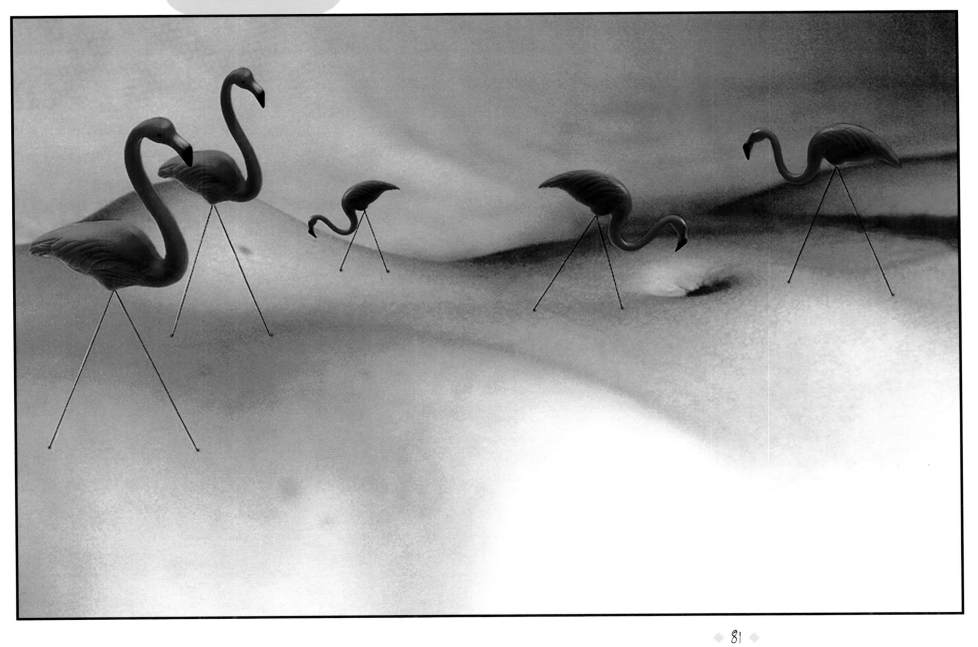

Temptation

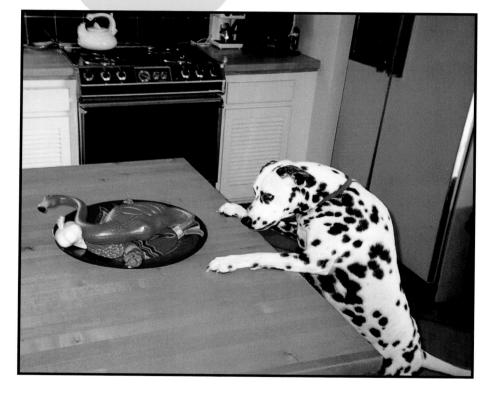

Nose to the Grindstone

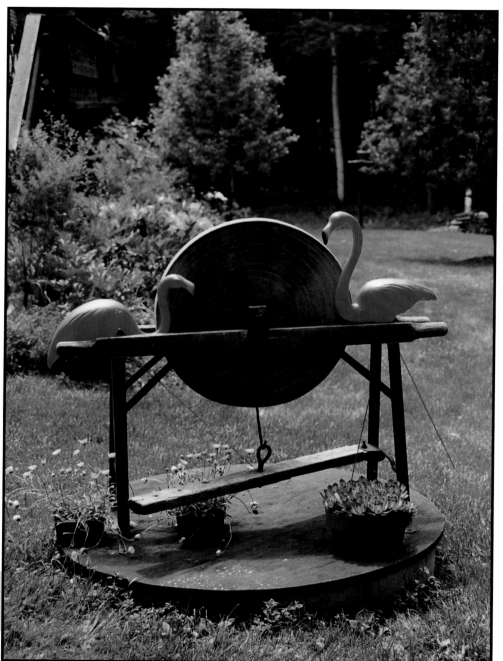

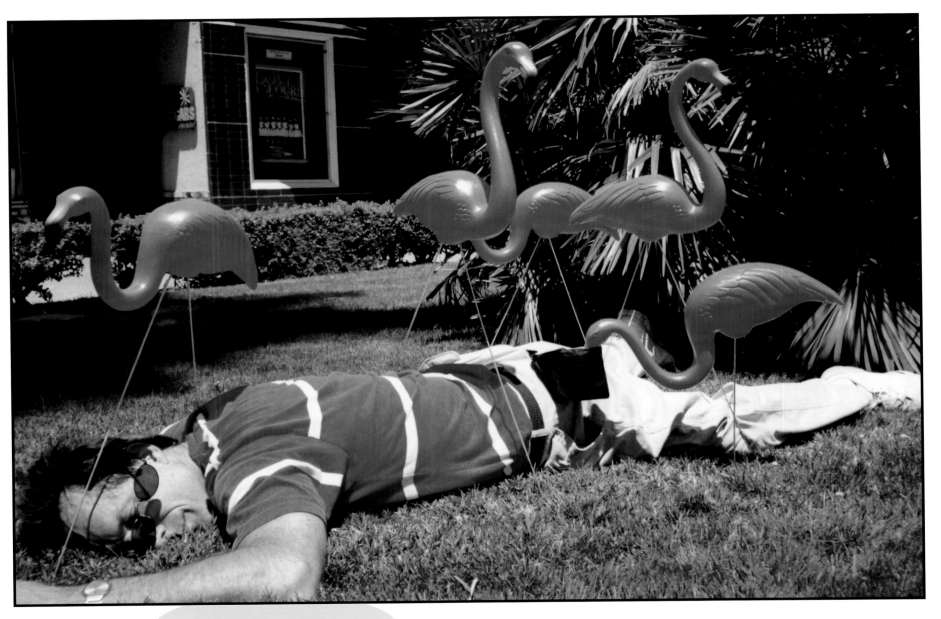

Pink Pick-Pocket

You Light Up My Life

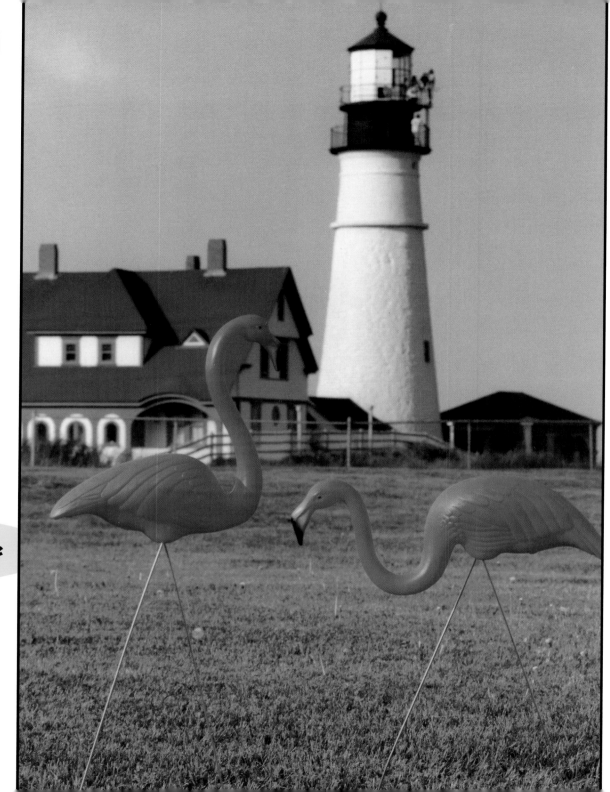

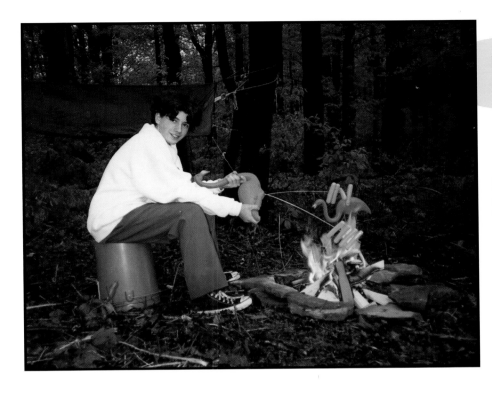

**Put Your Best
Foot Forward**

Forget It!

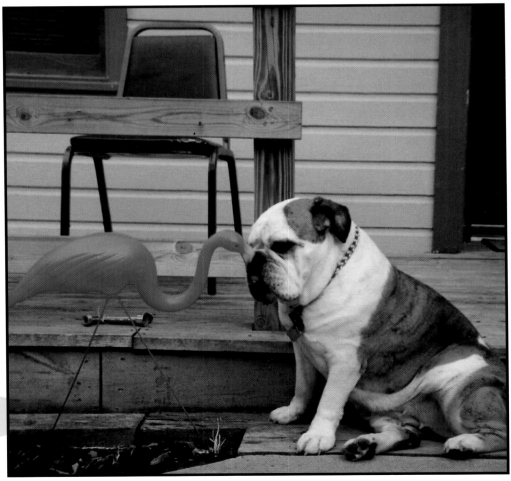

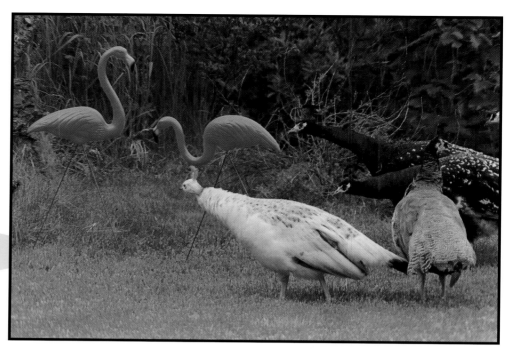

Unnatural Desires

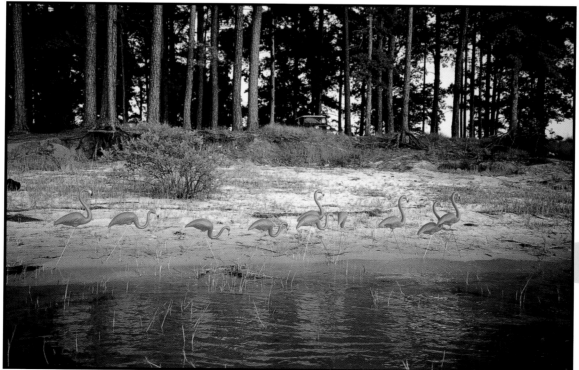

Follow the Leader

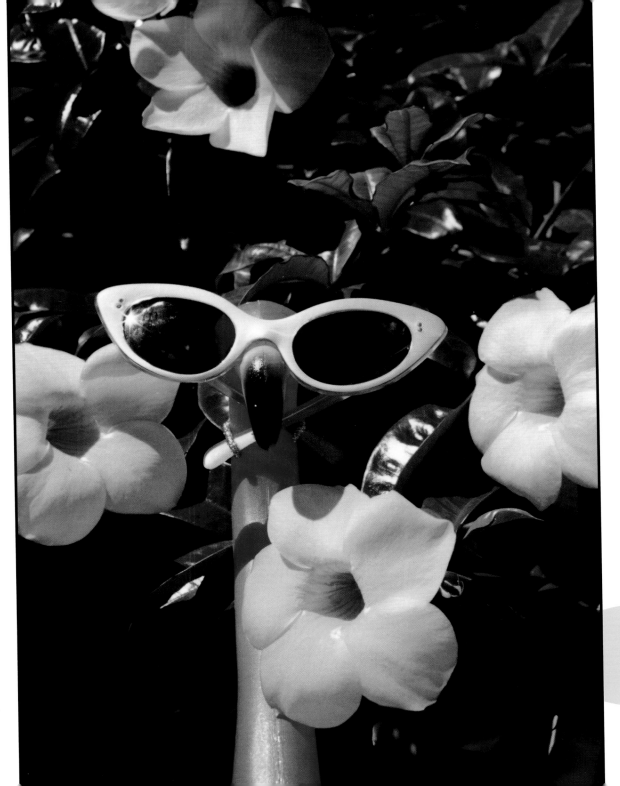

No matter how great a curiosity the pink plastic flamingo becomes, he never loses his "essence"...

Witness Protection Program

87

**Who Brought
the Volleyball?**

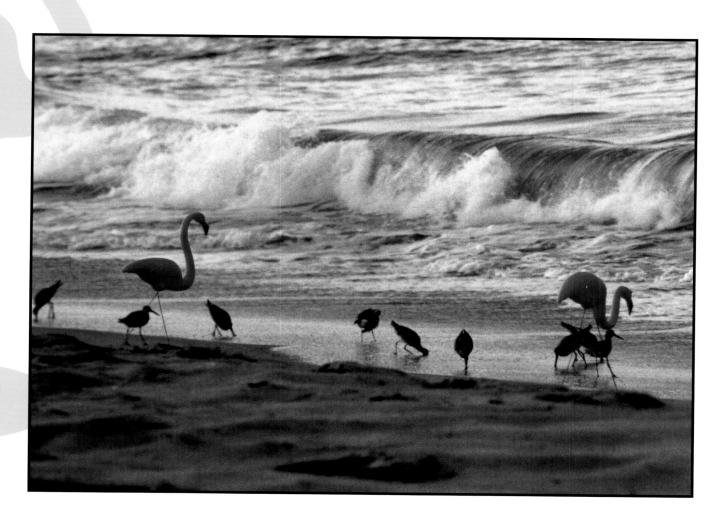

**Where the
Gulls Are**

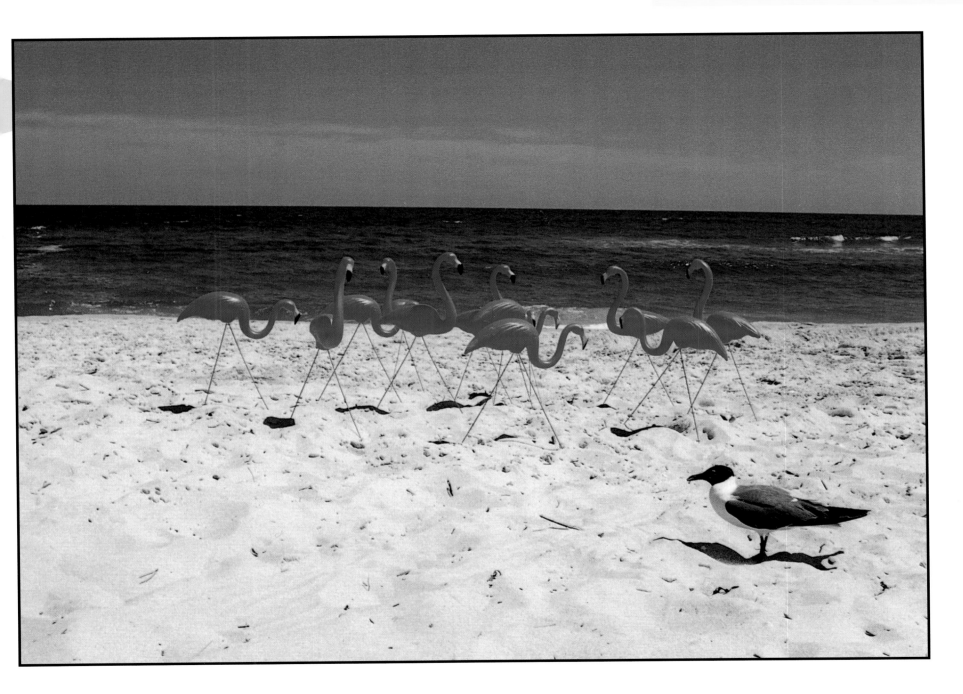

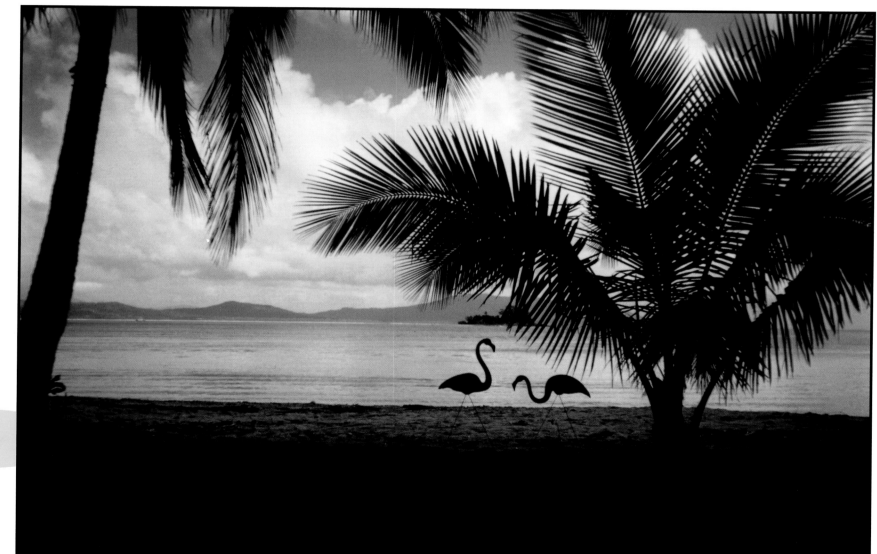

Castaways

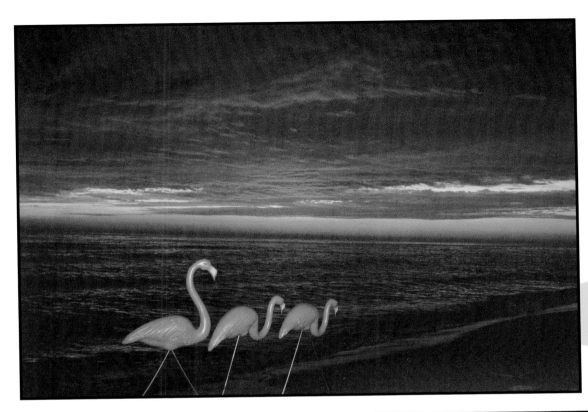

Red Males in the Sunset

Flamingo Honeymoon

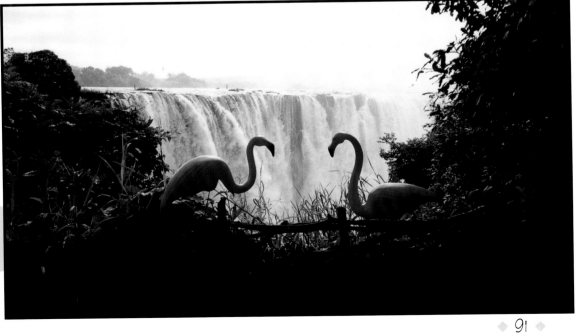

College Pickups

Beachcombers

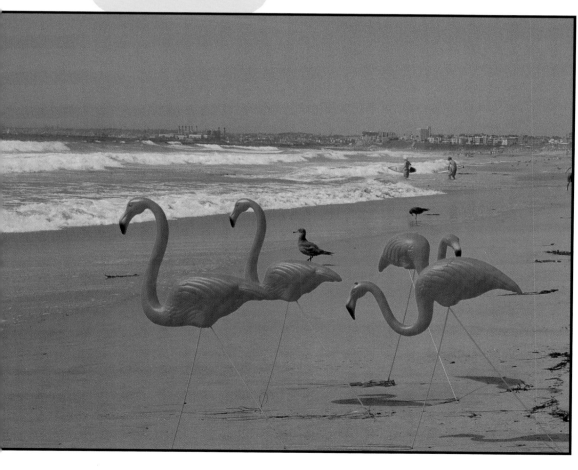

The Crimson Tide

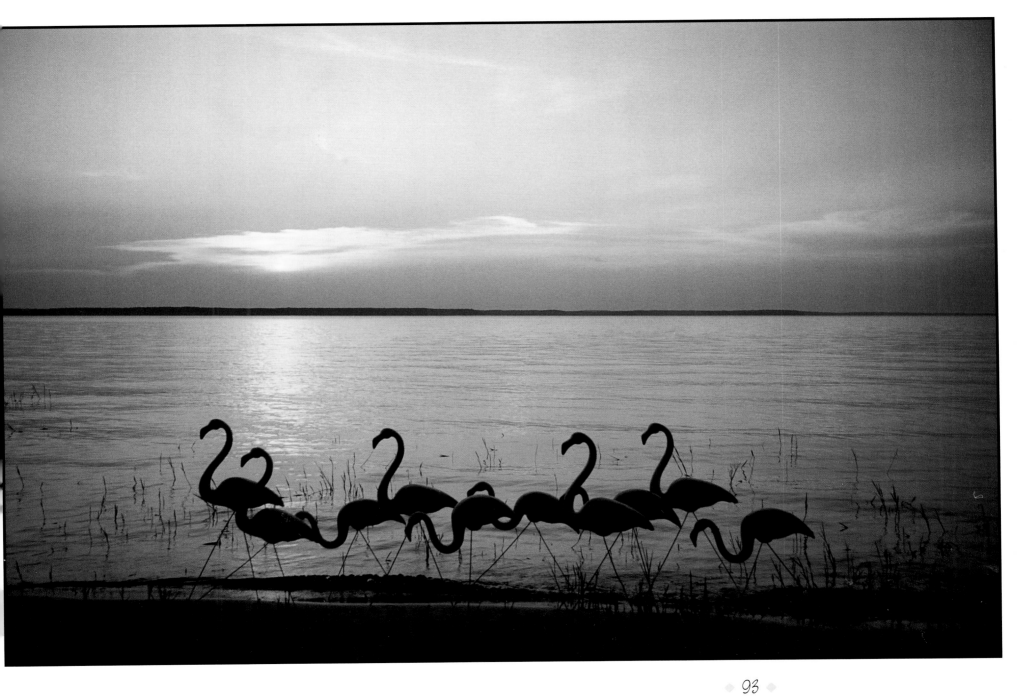

Photo Credits

About the author:

The Father of the Pink Plastic Flamingo

Don Featherstone was born to destiny in Worcester, Massachusetts on January 25, 1936, a month too late or eleven months too early to celebrate Christmas.

His parents indulged what appeared to be Featherstone's artistic temperament, sending him to private lessons and finally to the School of the Worcester Art Museum from which he graduated in 1957.

Though he seriously considered painting, sculpting, and starving in a freezing garret, Don Featherstone capitulated to reality and accepted employment with Union Products, a small firm in Leominster, Massachusetts that was producing two-dimensional plastic lawn ornaments. Their most popular figures were a white duck and a pink plastic flamingo. The owners hired the expensively educated and overtly sensitive *artiste* to render these two best sellers in three dimensions. The rest is seriously scary cultural pop history.

Recognizing Don Featherstone's contribution to the success of Union Products, the owners eventually made him national sales manager and Vice President and on the flamingo's thirtieth birthday engraved Featherstone's signature under the bird's tail.

In June of 1996, Don Featherstone and his partners bought Union Products, which continues to produce not only the infamous flamingo but a host of other lawn decorations including Easter, Halloween, and Christmas decorations.

Don Featherstone's fifteen minutes of fame still depends on his spindly-shanked, neutered, petroleum byproduct, which in just 40 years has vaulted from an object of derision to a culturally tolerated symbol of taste gone awry. Well done, father of *phoenicopteris ruber plasticus*!

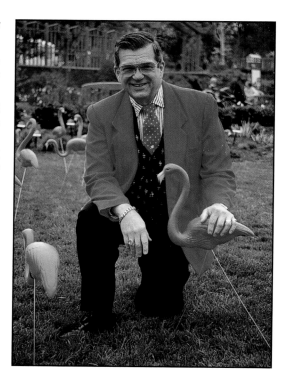

About the Writer

Tom Herzing is an emigré Thuringian nobleman whose ancestors fled the dissolution of the Holy Roman Empire. For years, he had ambitions of teaching at a Mexican University so he could be introduced to others as a Señor Professor but settled instead for a career as Professor of British Romantic poetry and academic administrator at a Midwestern institution of higher education.

Unbeknownst to his colleagues, he has written or edited books on subjects ranging from the use of Aristotlean syllogisms in rhetoric to the history of one of America's largest garbage truck manufacturers.

To no one's surprise, not a single one has been a popular success.

Undiscouraged, he keeps trying.